WIMBLEDON & SOUTHFIELDS

THROUGH TIME

Simon McNeill-Ritchie &
Ron Elam

AMBERLEY

Acknowledgements

The sources of information for this book were many, but include *Historic Wimbledon*, *Wimbledon: A Pictorial History* and *Wimbledon: Then and Now*, all by Richard Milward, *Wimbledon: Past & Present* by Patrick Loobey, and *Roomy Village* by Neil Robson.

Image Credits

All old images from the collection of Ron Elam.

All modern images taken by Simon McNeill-Ritchie.

For my family – because this is where our own 'history' began

For Hannah Elam and Trevor Sains

First published 2016

Amberley Publishing
The Hill, Stroud, Gloucestershire, GL5 4EP
www.amberley-books.com

Copyright © Simon McNeill-Ritchie & Ron Elam, 2016

The right of Simon McNeill-Ritchie & Ron Elam to be identified as the Author of this work has been asserted in accordance with the Copyrights, Designs and Patents Act 1988.

ISBN 978 1 4456 6105 6 (print)
ISBN 978 1 4456 6106 3 (ebook)

British Library Cataloguing in Publication Data.
A catalogue record for this book is available from the British Library.

Origination by Amberley Publishing.
Printed in Great Britain.

Introduction

Wimbledon

Wimbledon – to misquote fans of its famous FA Cup-winning football club – is a place of two halves. The name means 'Wynnman's hill', the final element 'dun' (don) being the Old English for hill. And the slopes of Wimbledon Hill mark a halfway line running north-east to south-west that divides the place into two distinct parts. Above, covering the crown of the hill, is Wimbledon Common, a broad plateau of woods and scrubland with nine ponds or *meres*. Extensive views in all directions may explain the site of a major Iron Age hill fort, the earliest evidence of habitation.

In the Middle Ages, Wimbledon was part of the manor of Mortlake which belonged to the Archbishops of Canterbury, who grazed their sheep and cattle on the Common. The gravel soil is poor, but gave the advantage of making it easier to sink shallow wells to reach the natural springs below. A good water supply was essential to any settlement, and it may be for this reason that Wimbledon Village first sprang up on the south-eastern corner of the Common, perched at the top of the hill and with panoramic views today over the modern town below. The arrival in 1574 of the great Cecil family heralded a new era for Wimbledon, and they were soon joined by other aristocratic families, most notably the Churchills and the Spencers. From the late eighteenth century, the imposing homes of wealthy statesmen and city merchants flanked the eastern and southern fringes of the Common, making Wimbledon a centre of Georgian society. Reflecting these developments, the village had grown into a bustling High Street, lined with shops and inns, and the introduction of stagecoach services from one of these, the Dog and Fox, made the journey to London a relatively simple matter.

It was the introduction of another form of transport, however, that triggered the rapid development of the land below the hill into today's town. In 1838, the opening of the London & South Western Railway brought with it a station, followed by further lines to Croydon (1855) and Tooting (1868). Finally, in 1889, the Metropolitan District Railway (now the District Line) was extended to Wimbledon from Putney. Inevitably, the location of the station progressively shifted the focus of Wimbledon's subsequent development away from the village and the Common to the town below. Wimbledon's population leapt from fewer than 2,700 at the time of the 1851 census to more than 40,000 by the end of the nineteenth century. Large numbers of villas and terraced houses spread over the low-lying land around the town centre, aptly named the Broadway, followed in rapid succession by factories, shops, churches and schools. Wimbledon's civic functions also flourished. A police station arrived in 1870, and a new fire station in 1904. Wimbledon Library opened in 1887 and was joined three years later by a new Post Office. In 1905, Wimbledon was accorded the status of a Municipal Borough, with its own Town Hall and Mayor.

After the Second World War, in a further major phase of construction, many of the remaining Victorian houses were sub-divided into flats or replaced with apartment blocks, while in 1965 Wimbledon itself was absorbed into the London Borough of Merton. After the 1970s and 1980s, when the town centre struggled to compete commercially, the redevelopment of the station and Town Hall into the Centre Court Shopping Centre in the 1990s has spurred renewed growth and seemingly unceasing development ever since.

The hill continues to serve as a useful metaphor for Wimbledon today; at the top, the village retains a comfortable café-style culture, replete with fashionable shops and bars, while the Common is a haven for golfers and dog-walkers. Below, the town around the station is a bustling suburban shopping centre, constantly on the move.

Southfields

Southfields lies in the midst of Wimbledon, Putney and Wandsworth, undisturbed and unknown to the rest of London. It is rediscovered briefly every year for a fortnight in June by spectators passing through Southfields station on their way to the All England Lawn Tennis and Croquet Club. Then, for the rest of the year, it lies largely forgotten.

The name derives from the old manorial system, in which it was known as the South Field of the manor of Dunsford, and dates back to at least to the year 1247. Yet, compared to the surrounding areas, Southfields was a late developer. Until much later in the nineteenth century, it was still mainly fields and today's roads, such as Wimbledon Park and Kimber, were just paths across them. Only after the arrival in 1889 of the District & London & South Western Railway on its way from Putney to Wimbledon did the area start to take off. The main housing developments at the time were the 'Southfields Triangle' and 'The Grid', north and south respectively of Replingham Road, which runs eastwards down the hill from the station.

On the surface, little seems to have changed since then. There are a few redevelopments and new school buildings along Merton Road, once another path through fields but today the main thoroughfare along Southfields' eastern edge. Otherwise, the neatly laid-out rows of predominantly Edwardian terrace houses seem unchanged and undisturbed from a century ago. Deep down, however, signs of change, still subtle and largely detectable only to long-term residents, are appearing. By the station, the preponderance of estate agents and the rumoured imminent arrival of upmarket chain stores confirm that the area has finally been spotted by young urban professionals seeking affordable housing, quality village life and good communication with the centre of London.

About the Authors

Simon McNeill-Ritchie lived for twenty years in the Battersea area, where he was a committee member of the Wandsworth Historical Society and Deputy Editor of the *Wandsworth Historian.* He also served on both the Council of the London and Middlesex Archaeological Society (LAMAS) and its Greater London Local History sub-committee. He is currently a First World War expert in the Rugby Football Union's Great War Commemoration Working Group. Simon has published four books, produced a DVD documentary and written several articles about aspects of local history in south London. He has an Advanced Diploma in Local History and is currently studying for a PhD in History at the University of Cambridge.

Ron Elam is a well-known local historian who has lived in Wandsworth for fifty years. He has collected many thousands of views of the streets of London showing life in the early years of the 1900s. He has also collected hundreds of prints reflecting life in Victorian London. His speciality is the areas of inner south and south-west London. He also has a considerable number of pictures of many others parts of Greater London. This book is his third on areas of south-west London.

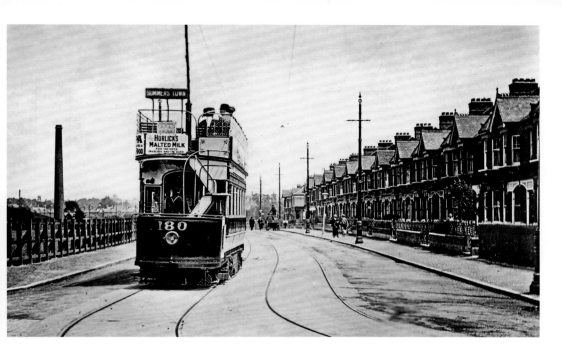

Plough Road

Looking eastwards along Plough Lane from the junction with Durnsford Road/Haydons Road. The flats on the left are built on the ground of Wimbledon FC, who played there from September 1912 to May 1991. The club then used the Crystal Palace ground, Selhurst Park. This ground continued to be used for reserve teams' home matches for both clubs. The stadium was demolished in 2002, and the flats built in 2005.

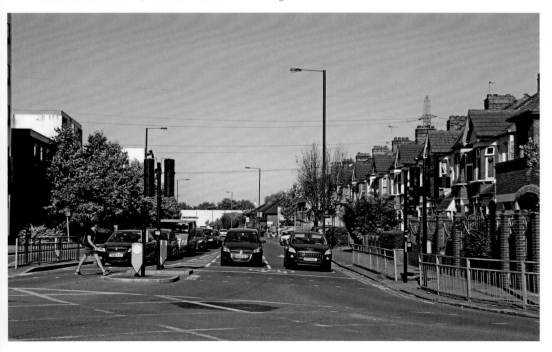

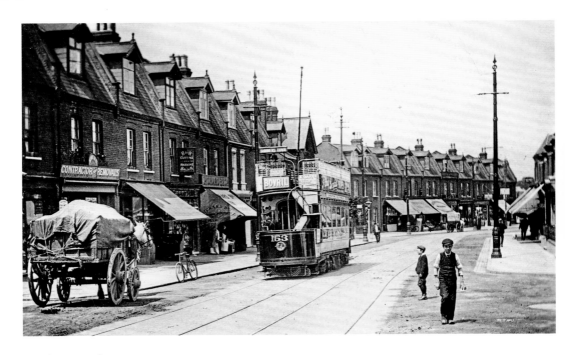

Haydons Road

The view looks to the north from the entrance to the railway station. The station opened in 1868, named as Haydens [*sic*] Lane, run by the Tooting, Merton & Wimbledon Railway. The small parade of shops in this road in the early 1900s would provide all that the local population required for their daily needs. The open-topped tram travelled between Wimbledon and Summers Town.

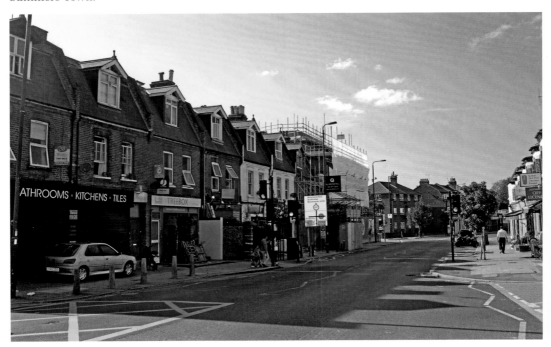

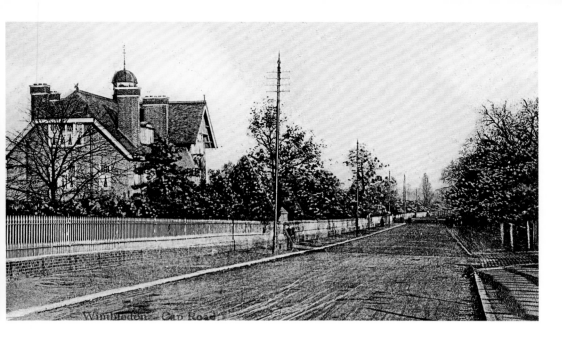

Gap Road

'Gap' is the latest in a series of name changes for this road, which began in the middle of the nineteenth century as Garratt Road. After Wimbledon Cemetery opened on the north side in 1876, it became Cemetery Road. Understandably, as new residents moved into the area, they sought a further change of name. Ironically, the graveyard has since been renamed to Gap Cemetery, after the road. The Wimbledon Isolation Hospital stood to the left of the house in the original image. It was built by the new Borough Council for £23,000 and opened in 1906 with eighty-two beds. When it was demolished, the Poplar Court housing estate was erected on part of the site beyond the building here.

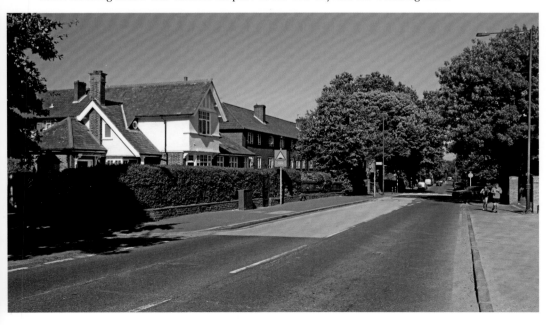

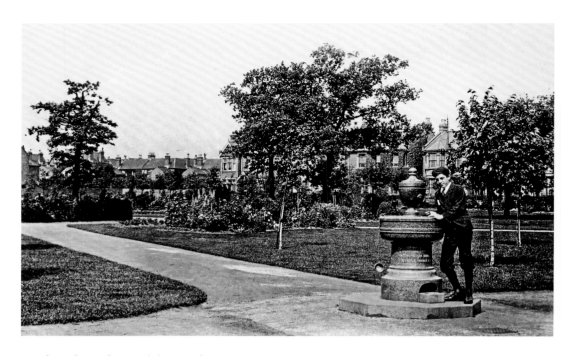

South Park Gardens, Trinity Road

These gardens were laid out in the late 1800s. By 1913, the gardens were surrounded by houses. The gardens were laid out with perimeter shrubberies, serpentine paths, scattered trees, a drinking fountain and a bandstand. They were restored to their current Victorian glory in 2009. English Heritage have registered it as Grade II.

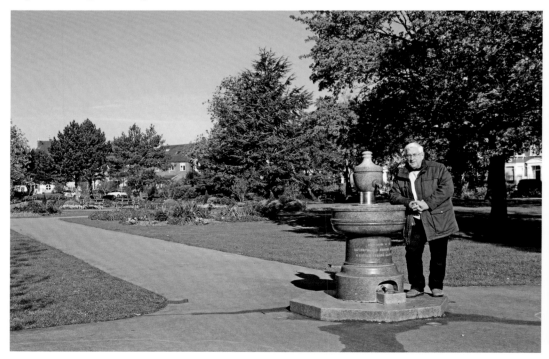

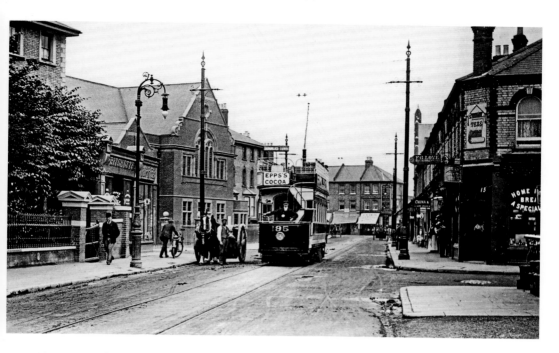

Merton Road

A tram passes along Merton Road towards Merton High Street, *c.* 1910. On the left is South Wimbledon Methodist Church, built in 1904 and since completely reconstructed with a striking curved three-storey façade on the corner with Griffiths Road. In contrast, the exterior of St Winifride's Roman Catholic Church (in the distance on the right), which was erected on the corner of Latimer Road just one year after the original Methodist building, remains very much unchanged.

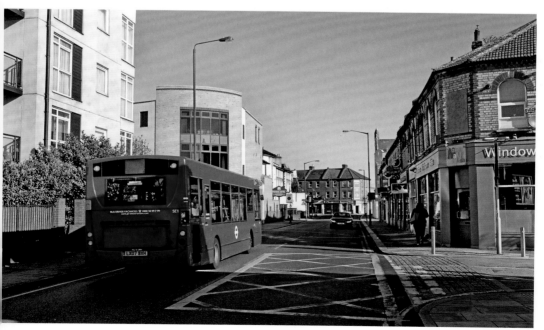

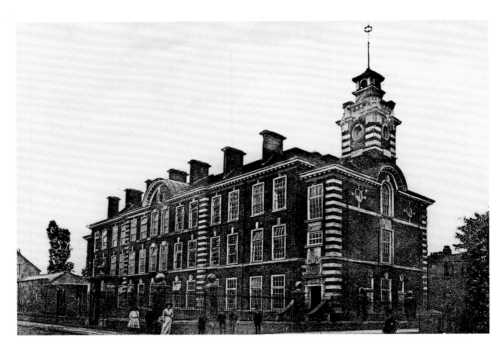

Pelham School, Southey Road

Designed in an early eighteenth-century Georgian style, Pelham Road School was built to cope with a rapid rise in Wimbledon's population and birth rate. It was opened on 14 July 1909 by England's Lord Chief Justice, Lord Alverstone, to 320 boys, 320 girls and 362 infants. However, on 22 July 1983, the school was closed because of falling enrolment numbers and the building was sold for private development. Renamed Downing's House in honour of the building's original architect, H. P. Burke Downing, it was converted into flats and reopened in 1990. A new primary school has been opened further down Southey Road.

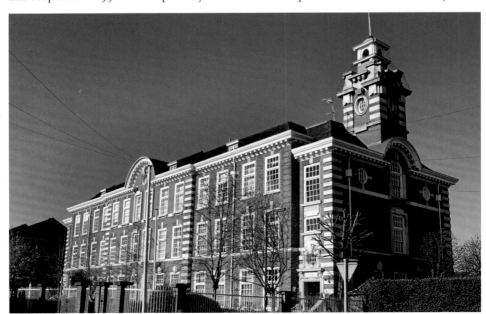

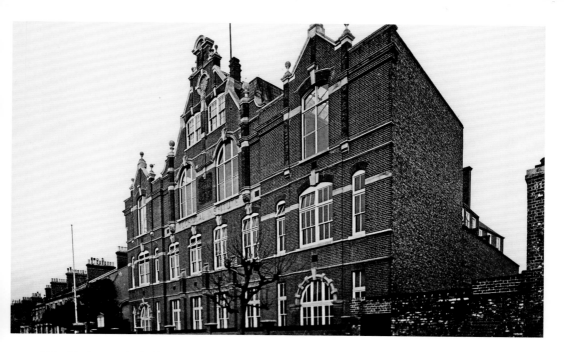

Wimbledon Technical Institute, Gladstone Road

Built near the southern end of the road, the Technical Institute opened in 1903 to provide a range of instructional classes to the influx of people pouring into 'New Wimbledon'. The Wimbledon College of Art moved there in 1904, and a Girls' Pupil Teaching Centre opened the following year. It changed its name to Wimbledon Technical College and later became Merton Technical College. The building was demolished in 1989 and replaced with flats.

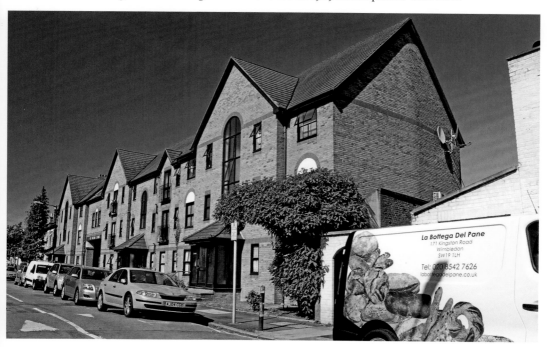

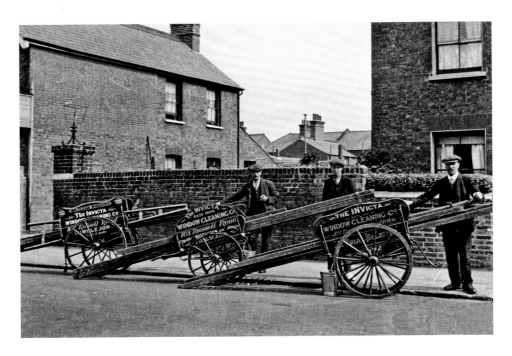

Window Cleaners, Russell Road

Three window cleaners pose somewhat self-consciously with their handcarts and ladders. The location of the image is unknown, but the details on their carts read 'The Invicta Window Cleaning Co. Est. 1904. G. Thorpe Manager. 103 Russell Road, Wimbledon S. W. Trial solicited'. Just in case there lingered any uncertainty, one of the carts helpfully confirms that 'We clean windows'. The bottom photograph, taken at the south end of Russell Road, imitates the setting of the original picture.

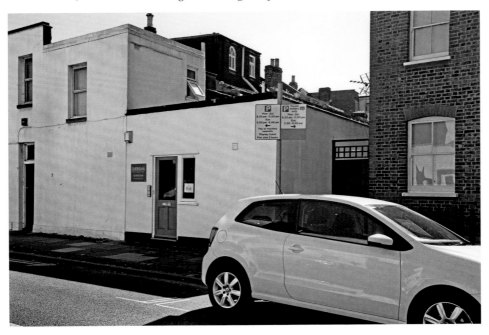

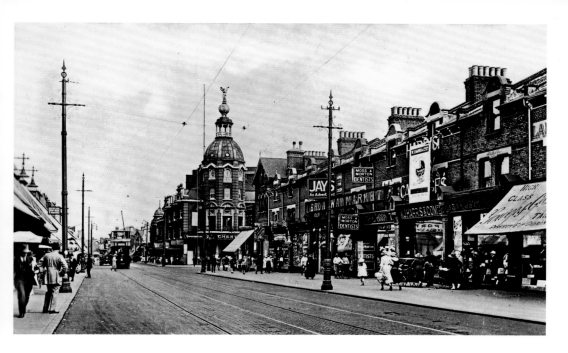

New Wimbledon Theatre, Wimbledon Broadway

The theatre was built in 1910 on the site of a large house with spacious grounds. It opened on 26 December 1910 with a performance of *Jack and Jill*, and pantomimes have been performed every year since then, with only two breaks: in 1941, because of the Second World War, and in 2003, due to refurbishment. The theatre was saved from redevelopment by the Ambassador Theatre Group in 2004 and retains its baroque and Adamesque interiors. The golden statue on top is Laetitia, the Roman goddess of gaiety. It is also an original feature, but it was removed during the Second World War as it was feared to be a navigation aid for German bombers.

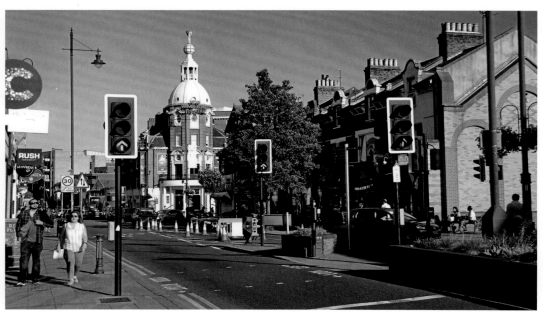

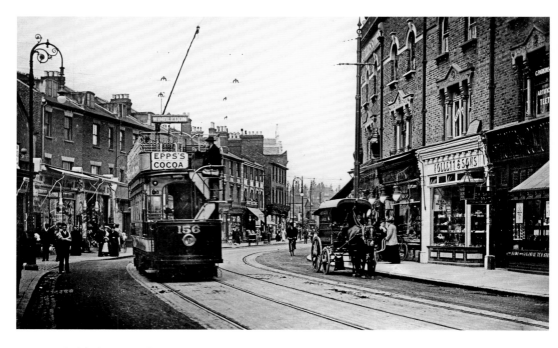

Tram, Wimbledon Broadway

The No. 156 tram trundles along the Broadway in 1907. At just 7 feet 2 inches wide, it took up a full 12 inches less of the road than its modern counterpart. The cake shop and the Home and Colonial Tea Store would face the patisseries and supermarket on either side of Wimbledon Piazza today. Presumably, the sign in the dental surgery above continues out of shot to read 'artificial teeth'!

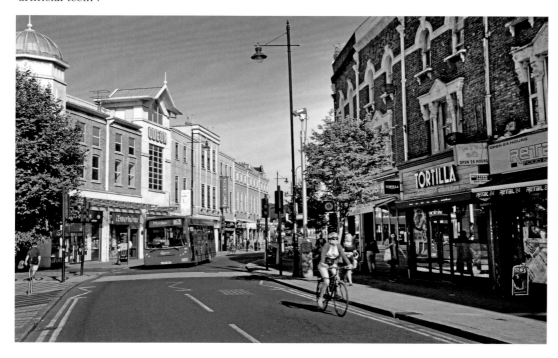

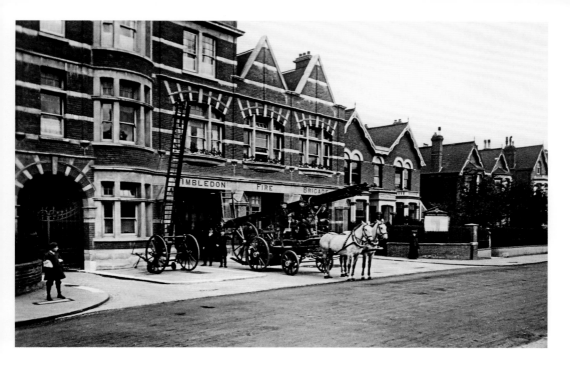

Fire Station, Queen's Road

After a disastrous fire at Cannizaro House in 1900, when it was found that the fire brigade did not have enough hoses to pump water from the Rushmere pond, the service moved to a new headquarters in the town centre, designed by Charles Hanlet Cooper and completed in 1904. A full-time professional force was established there in 1907. In 1989, a new fire station was built in Kingston Road to make way for the new shopping centre, Centre Court. It was initially proposed to demolish the fire station in Queen's Road, together with the Baptist church, but they were instead rescued and incorporated into the redevelopment.

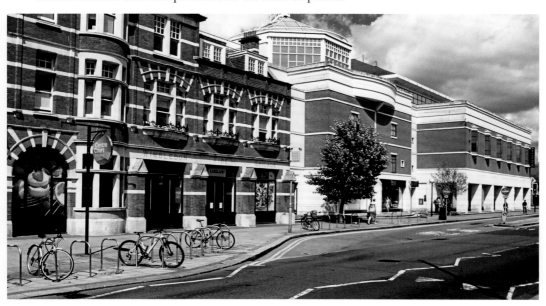

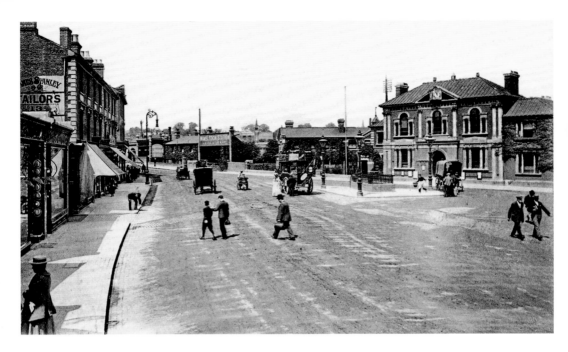

Town Hall, Wimbledon Broadway

The original building was built in 1878 as administrative offices for the local Board of Health and was adopted as the Town Hall in 1905 after Wimbledon achieved borough status. It was rebuilt and considerably enlarged between 1928 and 1931, after which it continued to serve as the administrative centre of Wimbledon until 1983. It was incorporated into the Centre Court Shopping Centre in the 1990s, at which time its façade was hidden behind newly planted trees.

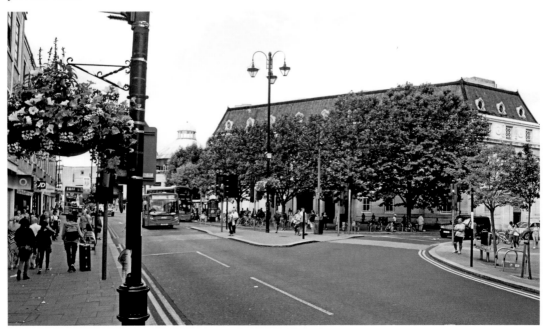

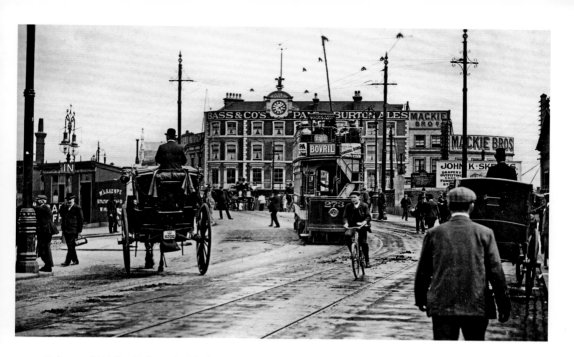

Prince of Wales Pub, Wimbledon Station

Increasingly encased in new developments, the Prince of Wales pub at the top of Hartfield Road continues nevertheless to present an impressive façade to pedestrians and traffic heading eastwards over the railway bridge. Built in 1867 and named after the future King Edward VII, the Prince of Wales presents as a classic Victorian town-centre public house, complete with ornate tiling and a clock. It stands on the site of an earlier seventeenth-century coaching inn, the kitchen, courtyard and cellar of which is today Bertie's Bar in a further reference to the former Prince of Wales.

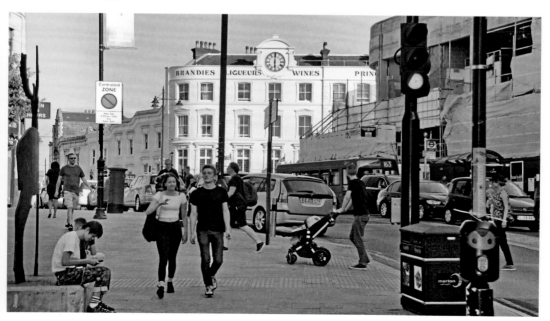

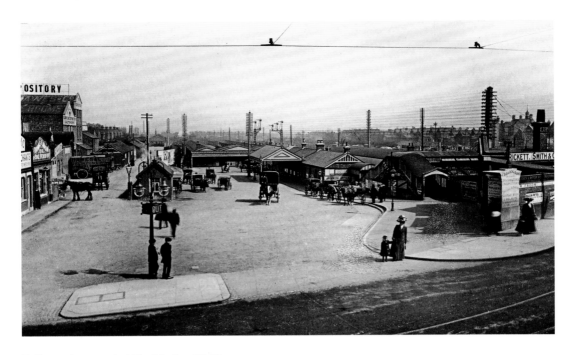

Railway Approach, Wimbledon Station

The station arrived in 1838 with the opening of the London & South Western Railway. Its location increasingly drew the focus of subsequent growth in the area away from the original village centre, towards the bottom of Wimbledon Hill. This process accelerated after transport links were expanded further with the opening of the Wimbledon & Croydon Railway in 1855, and the Tooting, Merton & Wimbledon Railway in 1868. The Metropolitan District Railway (now the District Line) was extended from Putney in 1889.

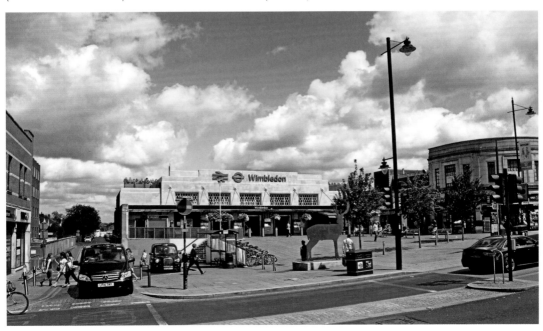

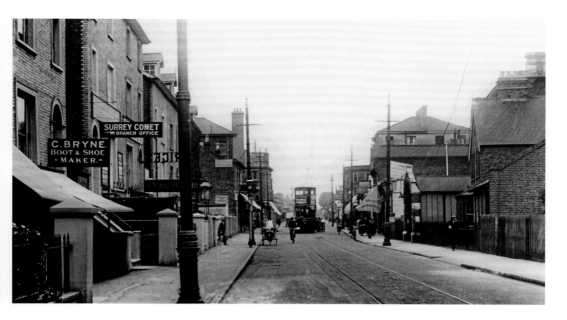

St George's Road

One hundred years ago, the Drill Hall in St George's Road played a central role in the community life of Wimbledon. The Drill Hall is first mentioned in 1882 as the headquarters of the Surrey Rifle Volunteers (3rd Wimbledon detachment) E & F Companies. But it was also used for civic occasions, such as a dinner held in 1890 for the Wimbledon Local Board to celebrate the extension of Worple Road, and a high tea for 500 people as part of the celebrations in 1905 to mark Wimbledon's promotion to borough status. During the First World War, it reverted to its military role, with a succession of regiments 'practising moving in formation' there before departing for the Western Front. Today, the site lies buried under the large office block of St George's House.

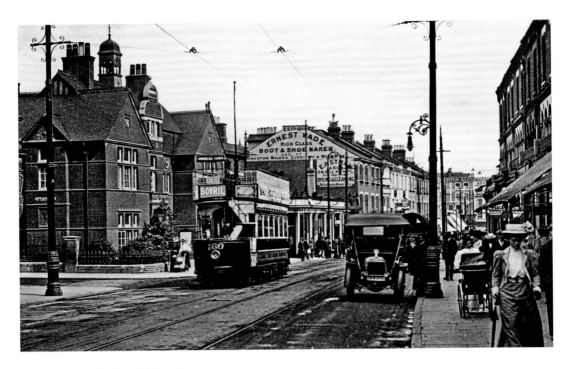

Library, Wimbledon Hill Road

Built to an Elizabethan-style design of red brick with stone detailing, the library stands on land once owned by Earl Spencer and bought in 1886 from its then owners, the Church Commissioners. The opening ceremony in March 1887 was attended by over 600 guests, including the eminent Victorian engineer Sir Joseph Bazalgette. The library proved very popular, and barely one year later, its librarian could claim over 2,000 members or one in twelve of the adult population of Wimbledon. In 1901, by a strange irony, the architect chosen to design the new extension was the son of the tenant forced to make way for the library in 1886.

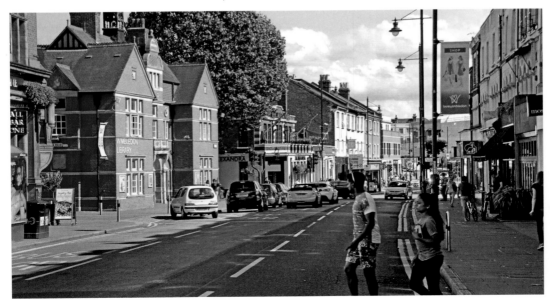

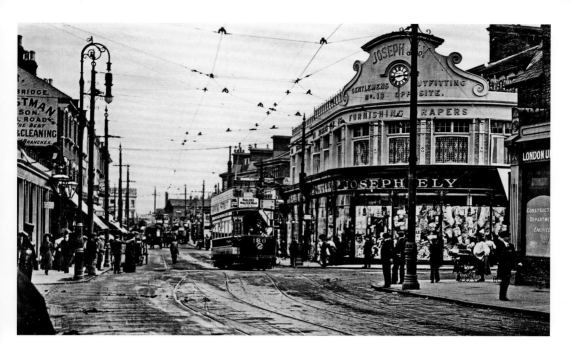

Ely's, Wimbledon Hill Road

Joseph Ely, 'tailor, outfitter and draper', opened his first shop on the corner of Alexandra Road in 1876. Ten years later, he moved to a second, much larger shop on the corner of Worple Road. The store-front was remodelled with a rounded corner in 1906/07 to accommodate the arrival of the electric tramway system, which brought new customers from neighbouring New Malden and Raynes Park. The store was rebuilt in 1986.

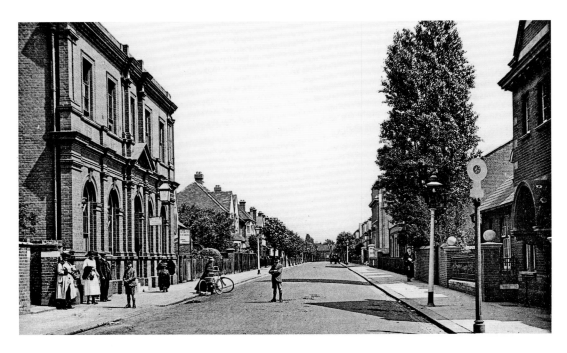

Post Office, Compton Road

Pillar boxes had first appeared in the 1850s. However, as Wimbledon had no official post office until 1879, the postman Samuel Syritt had to walk to Putney to collect the mail before starting his rounds. A new post office was built in Compton Street in 1890, by which time it made eighteen collections daily, between 8 a.m. and 10 p.m. It closed in 1995. The road is named after Lord Alwyne Compton, the Dean of Worcester in the 1880s, who nominally owned the land.

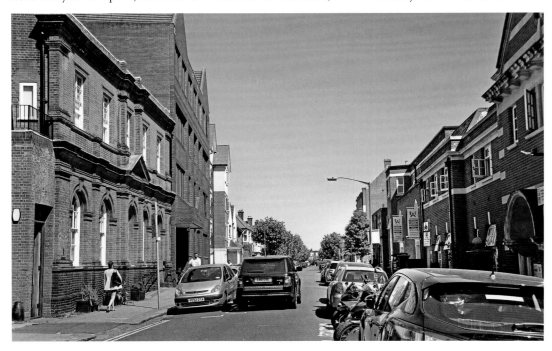

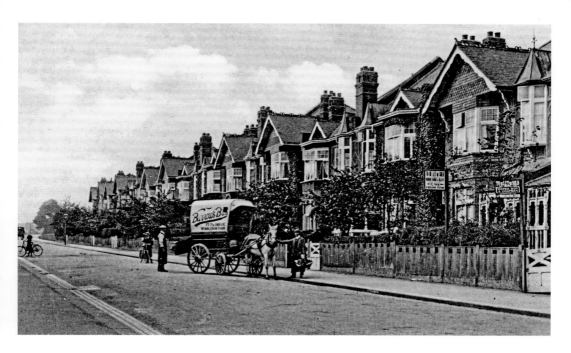

Dora Road

This view looks south from the junction with Home Park Road. This postcard was posted in 1907, highlighting a not unusual purpose at that time – to show a relative or friend where they now lived. The postcard is made more interesting by the presence of estate agents' signs. A delivery is being made by a business that could afford to have their own horse-drawn cart.

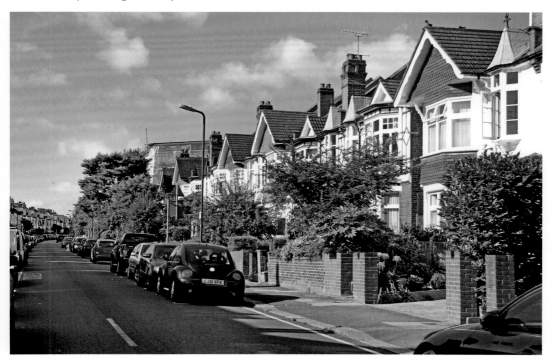

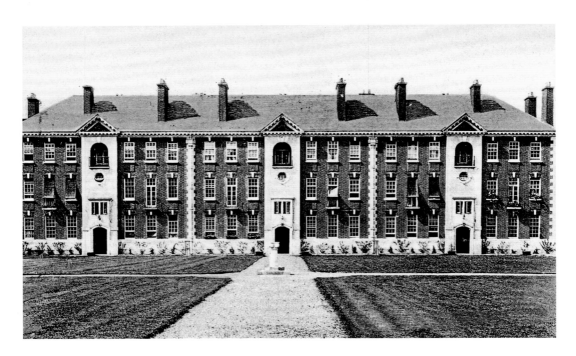

Queen Alexandra's Court, St Mary's Road
The court was originally built as homes for officers' widows and daughters following an appeal in 1899 by Col James Gildea, founder and chairman of SS(A)FA, the armed forces charity for the families of servicemen and women. The first women and children moved into the homes in 1904. Today, three apartment blocks set in attractive gardens provide independent living for seventy-six women – all widows, former wives or single daughters of officers in the British armed forces and – in a development since Gildea's day – for retired women officers.

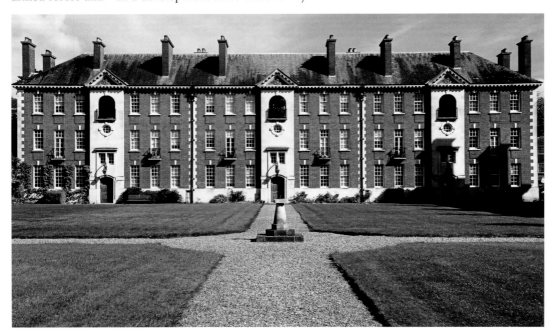

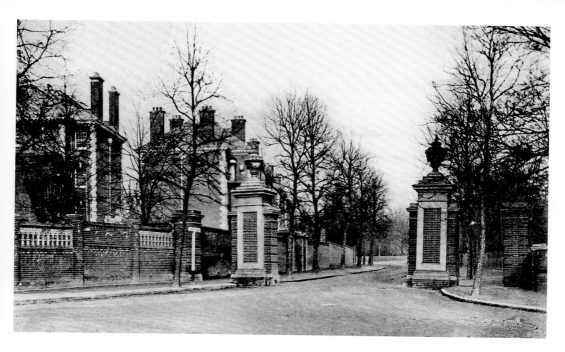

Entrance Gate, Wimbledon Park

This is a pair of large, brick-and-stone piers that are built on the edge of the carriageway of Lake Road. Their date is uncertain, but they could be late nineteenth century. The design suggests strong baroque influence. The main features of interest are the brick-and-stone detailing, and in particular the stone urns that cap the piers. While the piers are a very individual feature, they do complement the nearby listed Queen Alexandra's Court.

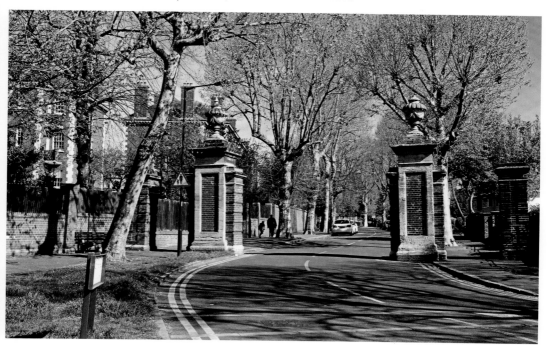

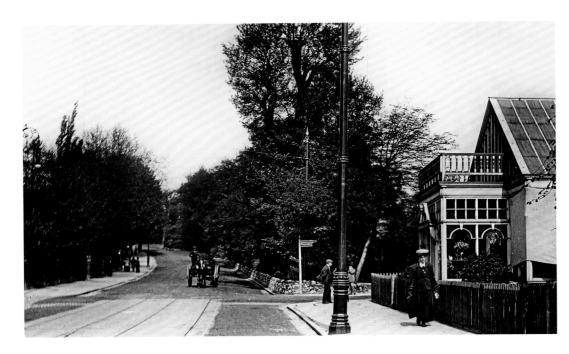

Wimbledon Hill and Woodside

On the right, on the corner with Woodside, stands the shop belonging to David Thomson, a Scottish gardener who settled in Wimbledon in 1838. After the Spencer estate was sold in 1846, he leased the fourteen-acre site of the 1st Earl's kitchen garden and converted it into a nursery. The business flourished, with Thomson's skills as a landscape gardener and plantsman in great demand from the owners of the large houses further up the hill. By 1871, Thomson employed ten men and two boys. However, in 1884 his lease expired, and the Church Commissioners decided to sell part of the land for the new library.

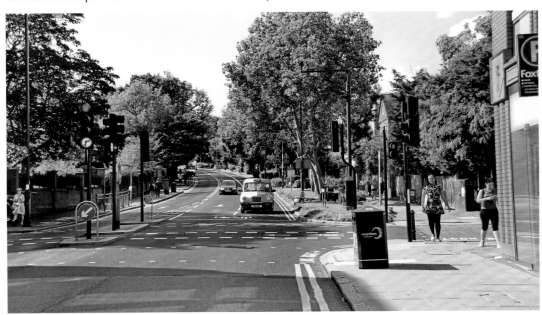

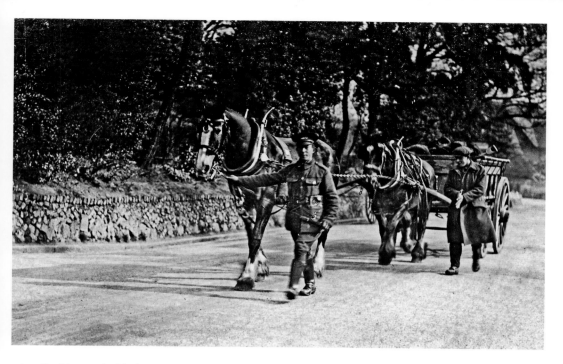

'Jack' on Wimbledon Hill

The steep incline on Wimbledon Hill necessitated a trace-horse, an extra horse hitched beside a team, to help pull coal carts and other heavy loads up to the village. The trace-horse here was always called 'Jack', even if a mare! Once at the top of the hill, Jack would refresh himself at the water trough before walking back down to his hut near the bottom of the hill.

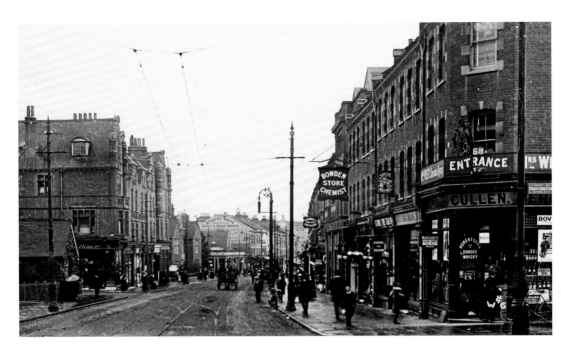

Wimbledon Hill Road

The 1880s shopping parade on the corner with Mansel Road was once occupied by small, family-owned establishments. It was demolished and replaced with the present office block in the mid-1990s – the people of Wimbledon today apparently having more need of estate agents than tailors and bootmakers. The tram tracks on Hill Road were closed in December 1932, and the terminus withdrawn to the (then) new Town Hall.

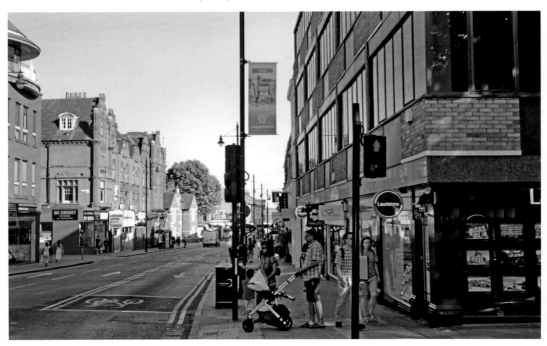

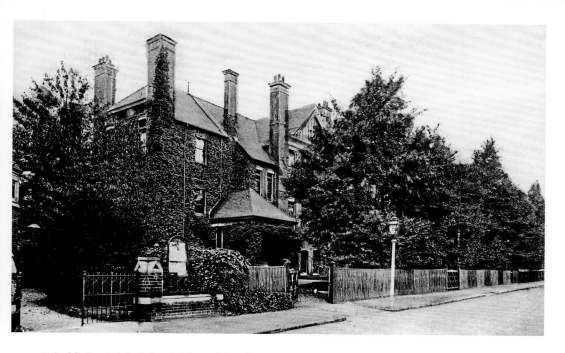

Wimbledon High School, Mansel Road

Wimbledon High School was founded by the Girls' Public Day School Trust and opened on 9 November 1880 with just twelve students. True to its motto, *Ex Humilibus Excelsia* ('From humble beginnings, greatness'), it grew rapidly over the following decade to more than 200 girls. The main building was gutted by fire in 1917, and a new building was formally opened in October 1920 by one of its old girls, the Duchess of Atholl. In 2000, a new junior school building was opened, including the Rutherford Centre for the Performing Arts, named after another alumna of the school, the actress Margaret Rutherford.

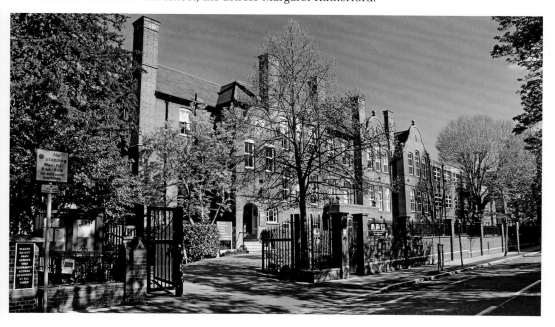

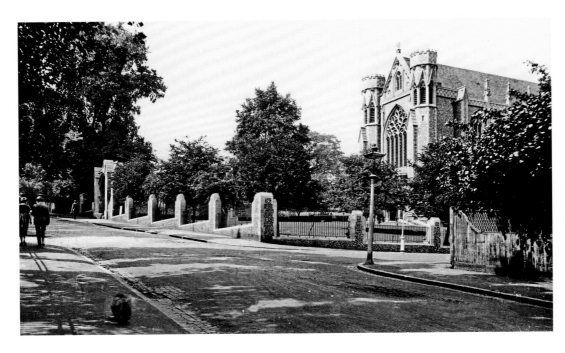

Sacred Heart Church, Edge Hill

Sacred Heart Church was founded by Edith Arendrup, who came to Wimbledon in 1877. Initially, Mass took place in her home. Building of the church started seven years later and was completed in 1901. The church is Grade II* listed. On the opposite side of the road is a detached house built in the 1860s. It was built as a lodge to 'Ivyhurst', a large detached house that was demolished in 1935 and replaced by a block of flats, Edge Hill Court.

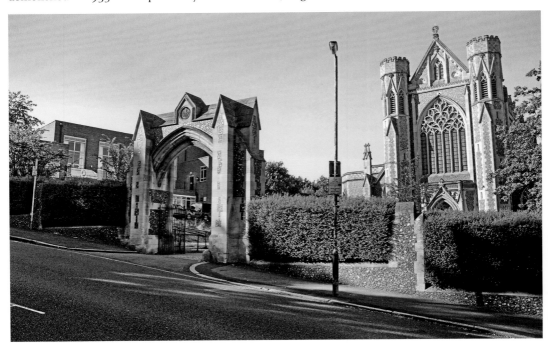

Edge Hill

On the earlier view, the five houses numbered 4–12 (even) can be seen through the trees. The houses date from 1884. Their design is based on a Jacobean classical style, including the detailing at the porch with its pilasters, the ridge tiles and terracotta finials, and the glazing bar patterns used in the sash windows. Other features are the moulded brick the bay windows, the brick detailing in various places and the stone at and above the porch.

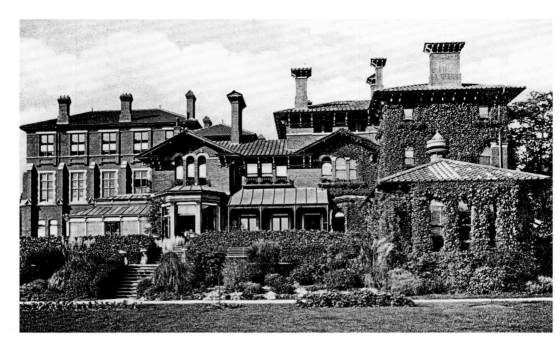

Ursuline Convent, The Downs

In 1892, the Ursuline High School, Wimbledon was founded when four nuns from Forest Gate came to Wimbledon to establish a tiny school with three pupils in a private house called Delaware at No. 68 Worple Road. The school soon expanded and moved to a large house called Claremont, pictured above. It is still visible from the school grounds but is now privately owned and separate from the main school site.

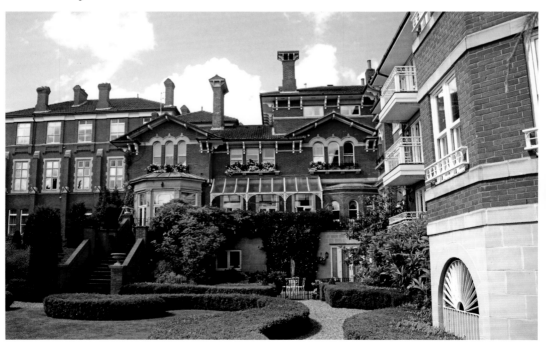

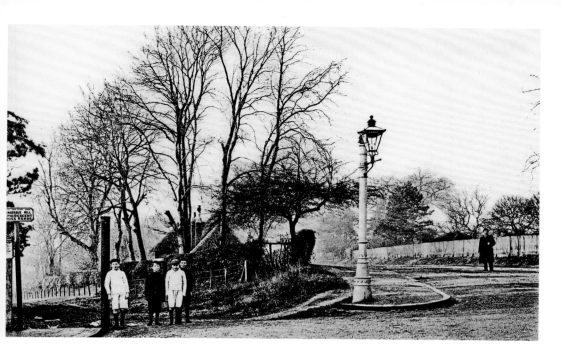

Cottenham Park Road

The area around this road is referred to in the Domesday Book, apparently being known as the Field of the Five Airs because the breaks in the North and South Downs allowed a flow of winds. The top picture shows the junction of Cottenham Park Road and Pepys Road. The children are standing at the start of what is shown on a 1920s road map as Church Lane but is now named (for at least part) as Orchard Lane, leading to Durham Road. Further along, No. 53 Cottenham Park Road is understood to have been connected to the first Roman Catholic chapel in Wimbledon. Presumably named after the former Lord Chancellor, Lord Cottenham, who owned a 300-acre estate in the area.

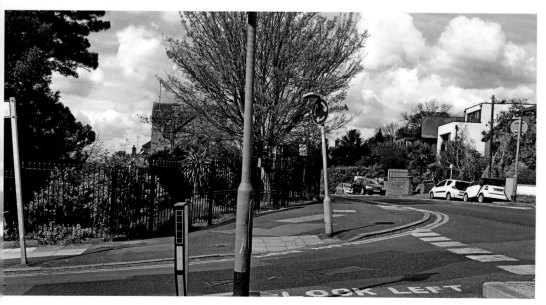

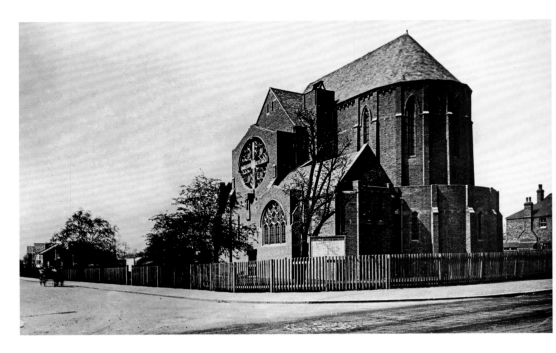

St Matthew's Church, Cottenham Park

At the corner of Durham Road and Spencer Road. From the 1800s, the congregation worshipped in a classroom, then a rented hall, followed by an iron church until a new church was dedicated in 1927. Destruction by a flying bomb in 1944 led to the rebuilding as the current building. (We recommend visiting the church's website, which has an excellent photographic history of the church.)

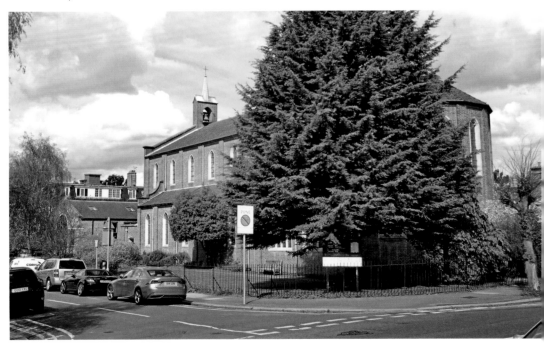

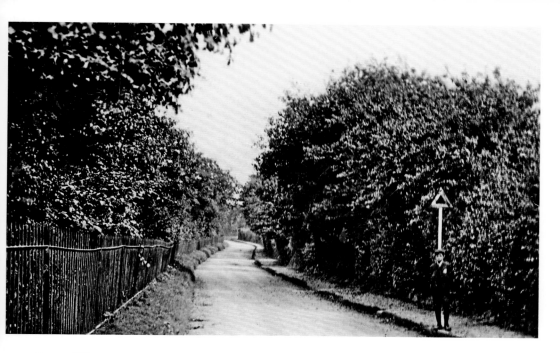

Copse Hill

In the 1830s, at the western end of this road, the Pettywad Wood lay on the southern side and the Wimbledon Wood on the north. Towards the turn of the century, the latter stretched from what is now Barham Road to near Wool Road. By that time, the wood to the south had disappeared with part of the land occupied by two large villas, Lindisfarne and The Firs.

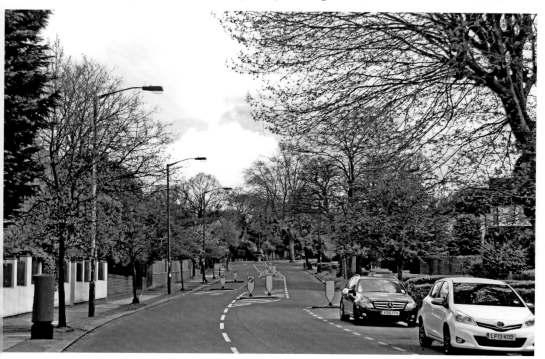

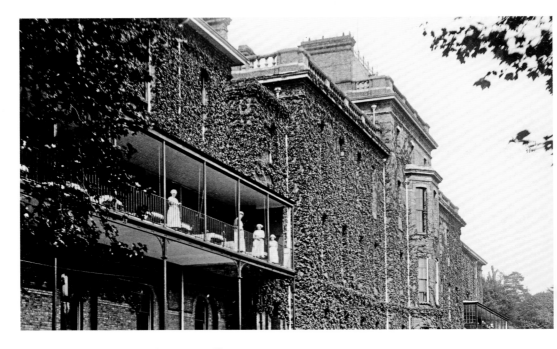

Atkinson Morley Hospital, Copse Hill

Atkinson Morley was a medical student in 1800 at St George's Hospital at Hyde Park Corner. A donation of £100,000 from him led to the new hospital opening in 1869 for convalescent poor patients. Patients with tuberculosis were able to sleep in the fresh air on the balconies. It remained a convalescent home until 1939 when it became a neurosurgery unit until 2003 and then provided a rehabilitation service until 2012. It is being restored and converted to luxury apartments by Berkeley Group and is called 'Wimbledon Hill Park'.

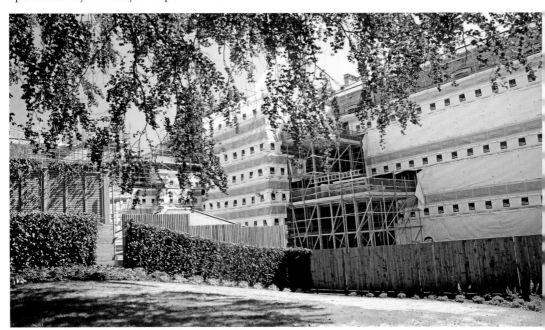

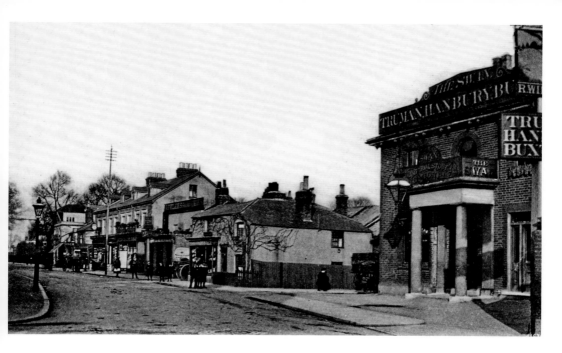

The Swan, Ridgway

On the right is the Swan Inn, with livery stables at its side where horses and cabs could be hired for a journey to the station. Two buildings to the left is the King of Denmark pub. Both public houses were started around 1860, though the King was probably the successor to a beer shop, the Jolly Gardeners. The imposing entrance to the Swan is said to have come from Cottenham Park House; it has since vanished. Beyond the King is Denmark Terrace, a line of shops also built around 1860. The King was rebuilt but was eventually demolished in 2012.

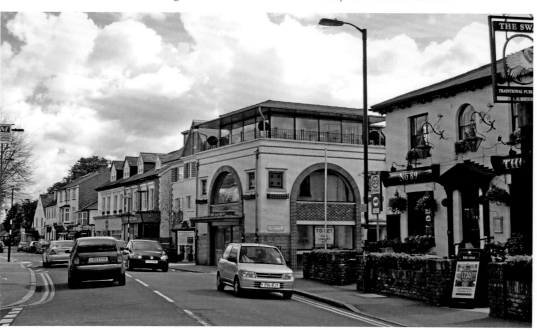

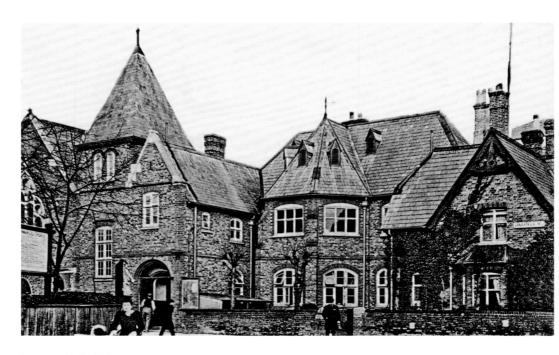

Lecture Hall, Ridgway

This building, 22 Ridgway, is at the corner of Lingfield Road. Wimbledon Village Club and Lecture Hall was established in 1858. Its purpose was 'to afford to inhabitants, and more especially the working and middle classes of Wimbledon and its vicinity, opportunities of intellectual and moral and rational and social enjoyment, through the medium of a reading room and library, lectures and classes'. It has strong links with many local community groups. The building also houses the museum of Wimbledon and the Norman Plastow Gallery.

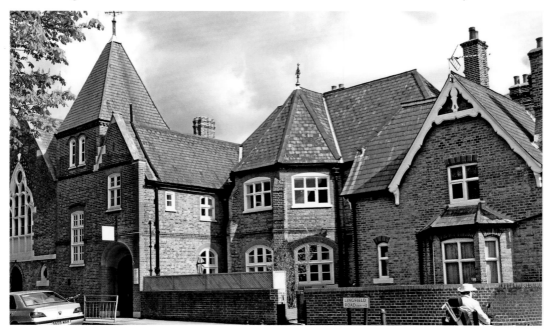

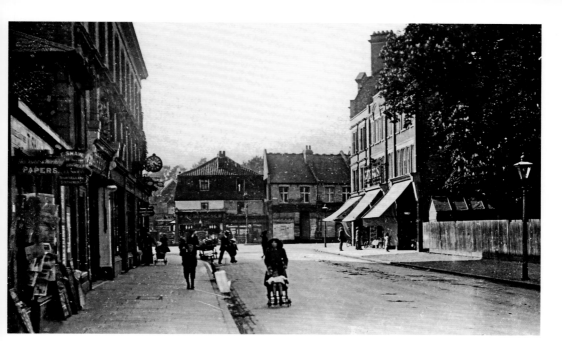

High Street (south), Wimbledon Village

The southern end of the High Street, facing north towards the junction with Church Street. The first shops began to appear in Wimbledon Village in the second half of the sixteenth century around the time that Elizabeth I became queen. By the time Charles II was restored to the Crown one hundred years later, it had already become a crowded, bustling thoroughfare, in which form it continues to this day. Nevertheless, in spite of the ongoing modernisation, earlier shop-fronts can still be seen on both sides.

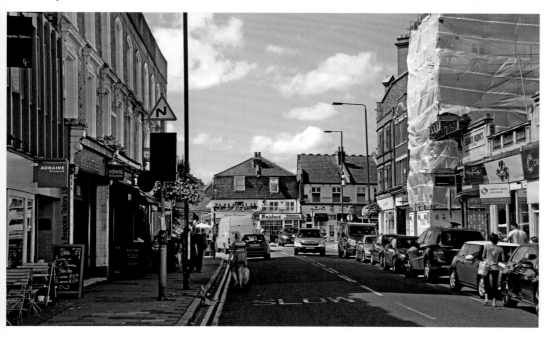

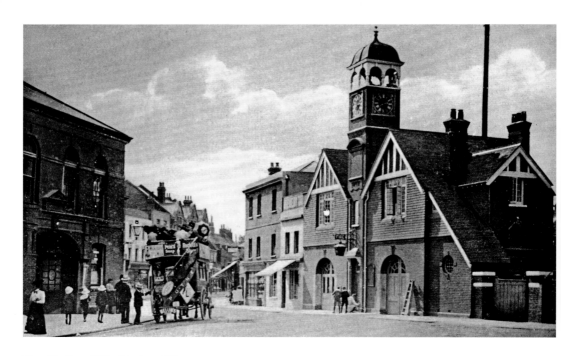

Fire Station, Wimbledon Village

Wimbledon bought its first community fire engine, a second-hand manual pump, in 1816, for which an engine house was built in the yard of the parish workhouse on Wimbledon Common. From 1869, volunteers protected the village using hand pumps, the fire station now housed in a small building in the stables adjoining the Dog & Fox pub in the High Street. With the town, the fire service grew steadily, and in 1890 an impressive new fire station of red brick, with gables, a copper cupola and a bell tower, was built in the High Street across from the Dog & Fox. By now, the service had twenty-eight volunteers and three steam fire engines, including a horse-drawn steam pump called *The May Queen*.

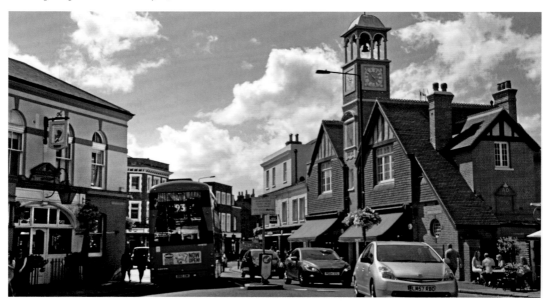

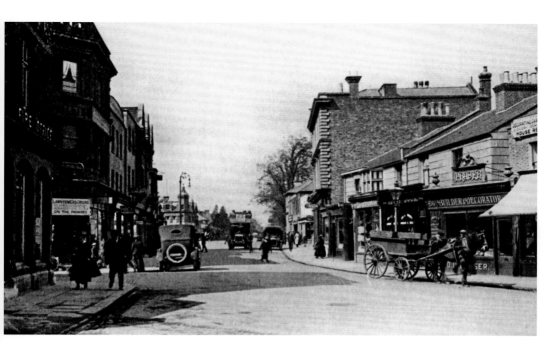

High Street (north), Wimbledon Village

The High Street looking north from the Dog & Fox. The pub is first mentioned in 1617, but the present building dates back to 1869. Many of the shopfronts are also from the nineteenth century, although several of the buildings are Georgian. The glaring anomaly is the five-storey office block that replaced the turreted shop of Thomas Mason, 'grocer and postmaster'. A fair was held every March, with stalls extending from the Dog & Fox to the Rose & Crown at the opposite end of the street. It was halted in 1840 after the 2nd Earl Spencer complained that it brought to the village 'all sorts of London blackguards'.

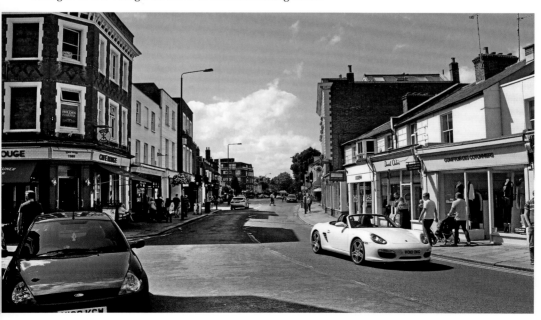

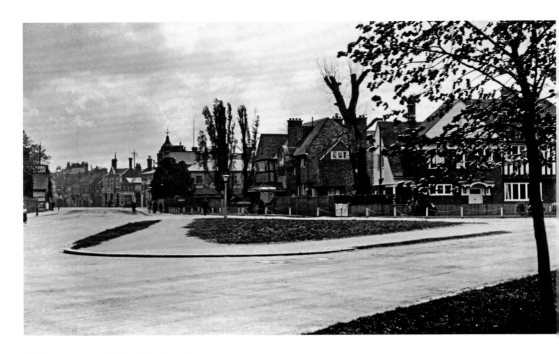

High Street and Wimbledon Common

At the south-eastern corner of Wimbledon Common at the top of Wimbledon Village High Street lies The Green. In the eighteenth century, it was the (second) site of The Pound, a wooden enclosure to hold stray animals found on and around the Common. A number of elegant houses have been built upon it since then, one of which was home to Sir William Congreve, the inventor of the eponymous artillery rockets used successfully during the Napoleonic Wars, and which he tested beforehand on the Common. Appropriately, a War Memorial (Grade II) was erected nearby in 1919 to the memory of Wimbledon men and women who have since perished in war.

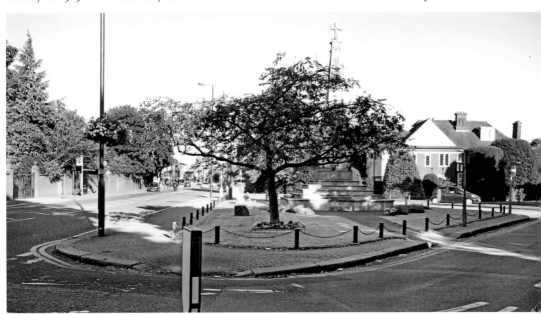

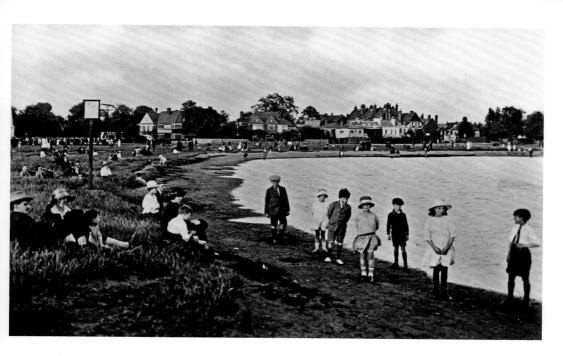

Rushmere Pond, Wimbledon Common

The pond was known as 'Rushmore' in Tudor times because of the rushes that grew around it, which were invaluable as materials for thatched roofs. It was also where villagers could keep their domesticated ducks. Wild birds also frequent the pond in summer, because even during periods of severe drought it does not dry up. For the same reason, the pond is a popular place to spend a sunny afternoon and today's waders are therefore just as likely to be human or canine.

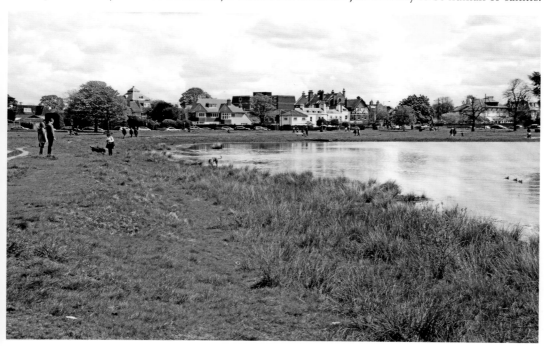

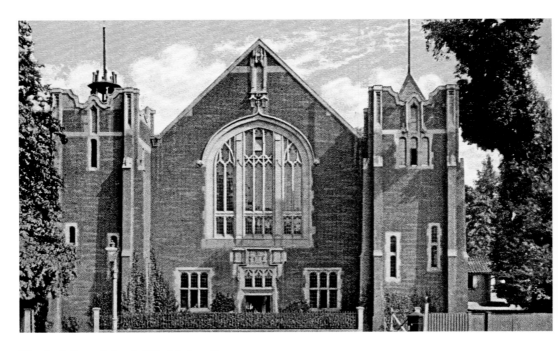

King's College School, Wimbledon Common

King's College School was founded in 1829 as the junior department of King's College London in The Strand. It moved to Wimbledon in 1897, and two years later, on 6 July 1899, the Duke of Cambridge opened the Great Hall. It was designed in red brick with cream stone by the eminent architect Professor Banister Fletcher; his father, Banister Fletcher (Senior), sadly missed the occasion, having died the previous day. One of the school's famous alumni was Roy Plomley, who devised BBC Radio 4's *Desert Island Discs*.

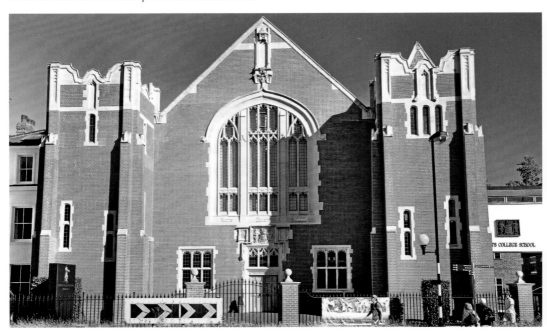

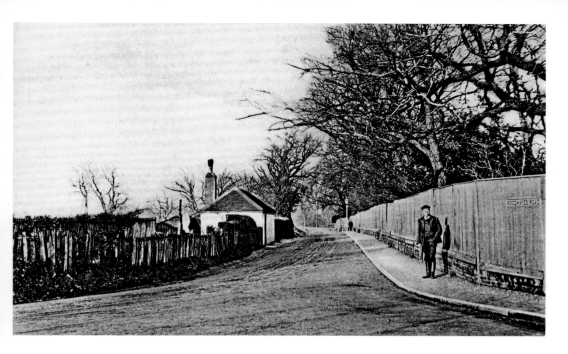

Old Cottage, Woodhayes Road

Just below King's College School on the right of the image lies the entrance to an historic lane called Wright's Alley. Named after Robert Wright, a resident in the early part of the nineteenth century of neighbouring Southside House, a survey of 1617 described it as 'a lane leading out of the Common to the common field through land called "Ward hawes"', the origin of the name Woodhayes. Southside House, now named Gothic Lodge, is just visible behind the white cottage on the right below. It bears a Blue Plaque to Sir William Henry Preece (1834–1913), a pioneer of the English telephone system who allowed Marconi to set up a transmitter in his garden to send some of the earliest telegraph messages. It was London's first house with a telephone.

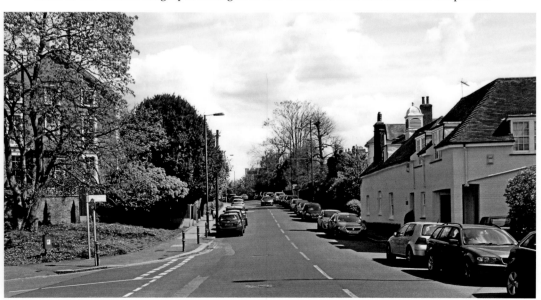

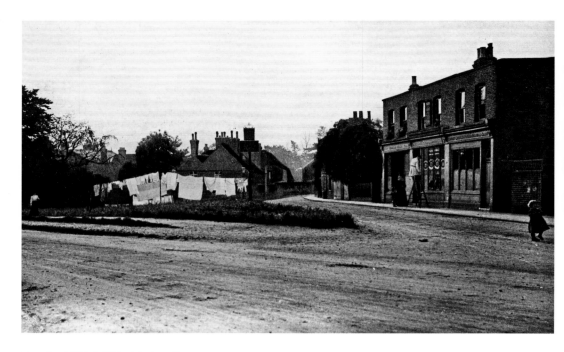

Crooked Billet, Wimbledon Common

A brewery and inn are first mentioned in 1509, although the first authenticated date of an alehouse on the site of today's pub is 1776. It had become known as the Crooked Billet by at least 1838, after a nearby pub with the same name closed. Daniel Watney, founder of the famous brewing family, moved here in 1730 and lived on the neighbouring site of what is today the Hand in Hand pub. The current building dates back to 1835 and was originally a bakery. The Cinque cottages in the background were built in 1872 by Sir Henry Peek MP for 'poor men of good character in needy circumstances' – a description that might serve for the pubs' customers today!

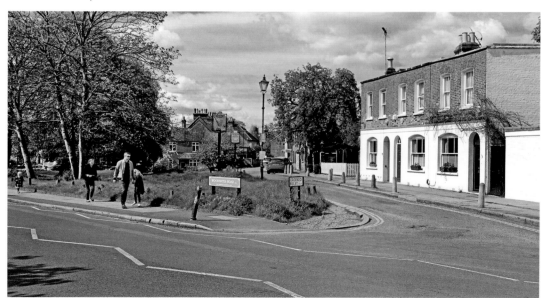

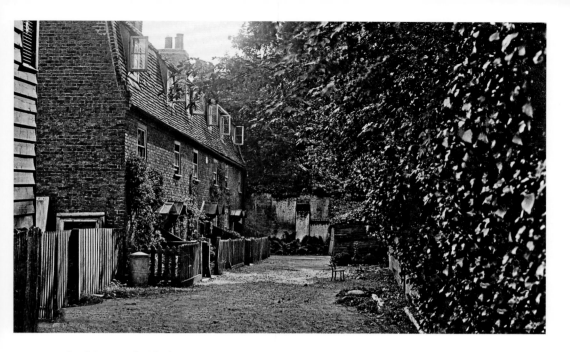

Hanford Row, Wimbledon Common

Set back from the Common, down a narrow track alongside the southern edge of Cannizaro House, this row of six cottages is named after their builder William Hanford. Built in the 1760s as modest accommodation for labourers, the original roofs have since been canted forwards to create a steep Mansard with dormers, giving them an effective third storey. Notwithstanding this, they still retain much of their original character, including ornamental porches over the front doors, that justifies their Grade II listed status.

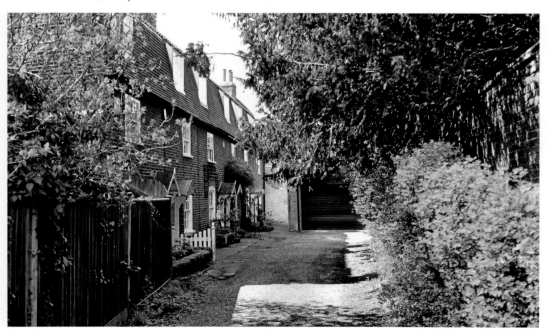

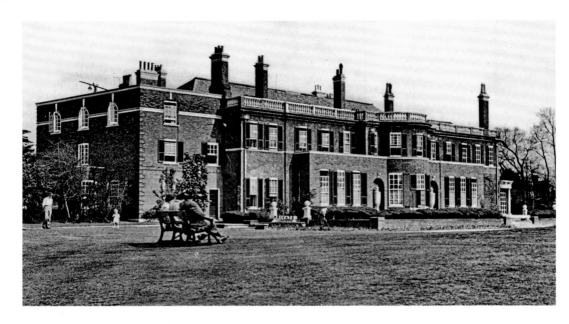

Cannizaro House, Wimbledon Common

Built in the eighteenth century and originally known as Warren House, for most of its history it was let to a succession of wealthy tenants, who made it a centre for Georgian society. From 1817, the Sicilian Count St Antonio and his Scottish wife Sophia continued the practice, acting as hosts to guests such as the Duke of Wellington and Mrs Fitzherbert, mistress of King George IV. After the count returned to Italy in 1832 when he inherited the title Duke of Cannizzaro, the newly elevated duchess remained at the house until she died in 1841. The house came to be known by her husband's title (albeit misspelt). In keeping with its tradition for hospitality and entertainment, Cannizaro House is today a hotel.

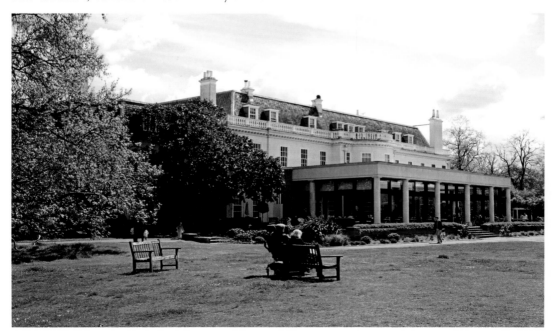

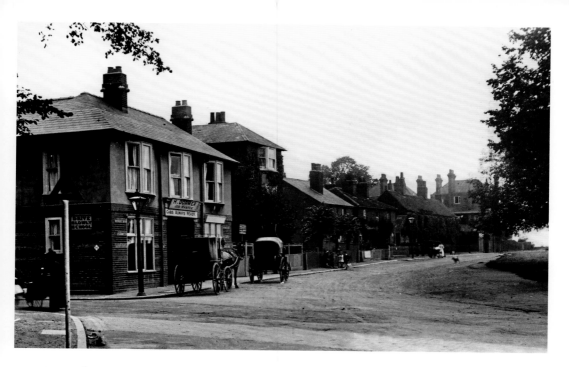

West Place, Wimbledon Common

Two hire carriages stand outside H. Dormer's Job Master's office. Reflecting the rapid developments of the time, it had recently been known as Dormer's 'Livery and Bait Stables, Broughams and Carriages (for hire)' and would shortly be renamed the Wimbledon Horse, Carriage & Motor Co. It stood over the yard built in the early nineteenth century by William Croft, a builder who bought or rebuilt many of the cottages on West Side. His son George probably built the large early Victorian house next door, known as the Hermitage (No. 10), as a family home. The prolific Scottish novelist and historical writer Mrs (Margaret) Oliphant died there in 1897 while watching the Jubilee celebration for Queen Victoria.

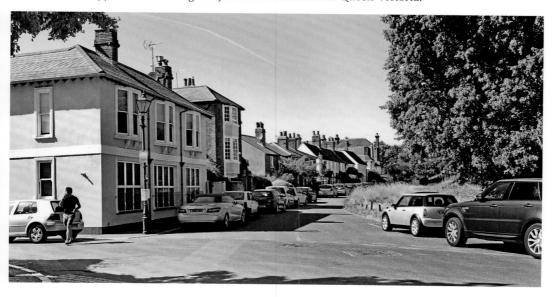

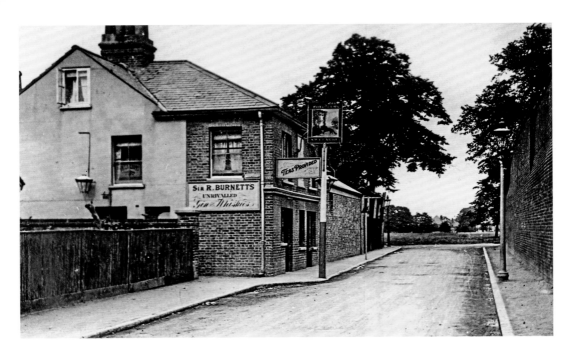

The Fox & Grapes, Wimbledon Common

The Fox & Grapes dates back to the eighteenth century and claims to have become Wimbledon's first gastropub in 2011. It can also lay claim to being the first home of Wimbledon FC, formed in 1889 as Wimbledon Old Centrals by the old boys of Old Central School, also in Camp Road. They played their first football on various pitches around the Common and used the Fox & Grapes (and The Swan on Ridgway) as their changing rooms.

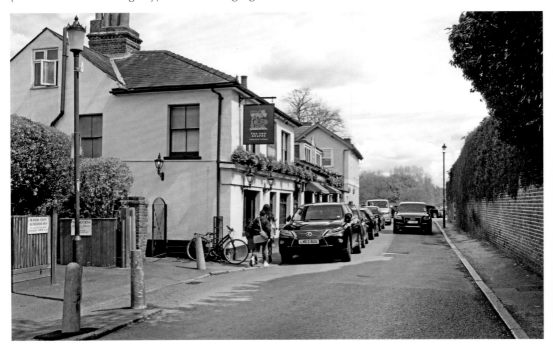

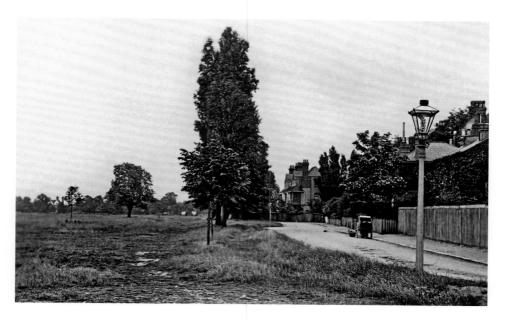

North View, Wimbledon Common

Given the present-day house prices, it is ironic that this area is close to the site of a former workhouse, built in 1752 to house about fifty 'impotent poor ... with proper economy'. A school was built alongside six years later, the octagonal structure of which is still visible as part of Wilberforce House which belongs to The Study, a preparatory school for girls. Blue Plaques identify No. 8 North View as the former home of Josephine Butler, the Victorian feminist and social reformer, and next door the home of Ernst Boris Chain, joint winner of the 1945 Nobel Prize in Medicine for the discovery of penicillin.

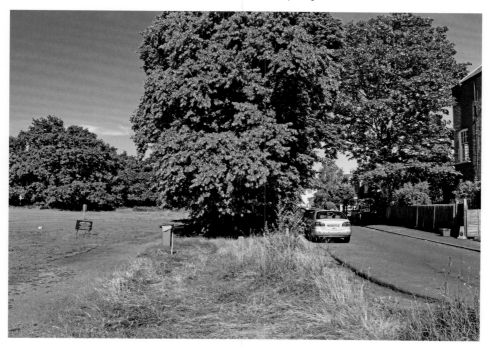

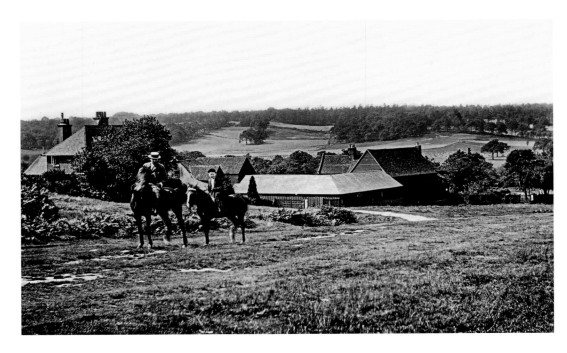

Warren Farm, Wimbledon Common

Standing on the western edge of the Common where once it overlooked Beverley Brook, Warren Farm is one of the earliest surviving buildings in Wimbledon. It is first mentioned in a 1617 survey as 'the house where the warrener lives' – this was the man who bred rabbits for their meat. By the 1740s, it had increased to over 130 acres with 20 fields. From 1785 until 1801, it was home to Thomas Watney, son of Daniel and founder of the Wheatsheaf Brewery nearby. The farmland was sold off in 1907 to the Royal Wimbledon Golf Club, but the buildings remain and have been modernised and extended to create an impressive private residence.

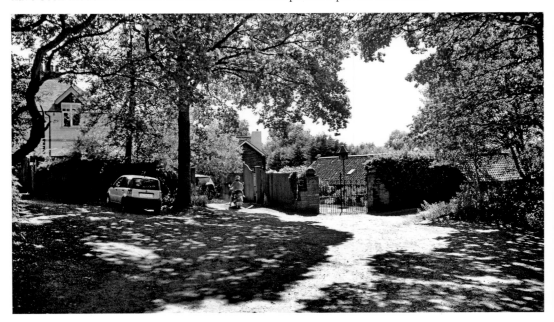

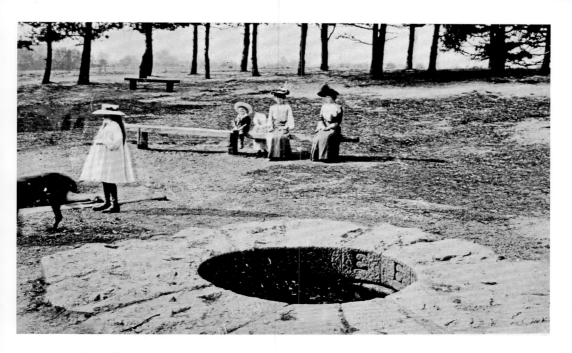

Caesar's Well, Wimbledon Common

The discovery of Neolithic arrowheads and knives in the vicinity shows that the spring was used from the earliest times. However, like Caesar's Camp nearby (in fact, an Iron Age fort), it was never visited by Caesar himself. The water was so pure that it was believed to have special medicinal qualities, such that in 1829 the Well was encased in brick and a surveyor sent to investigate whether the water could be brought to Chelsea by aqueduct over the Thames (it couldn't!). In 1872, after successfully fighting off Earl Spencer's attempts to enclose the Common, Sir Henry Peek MP installed the granite blocks that still surround the well today.

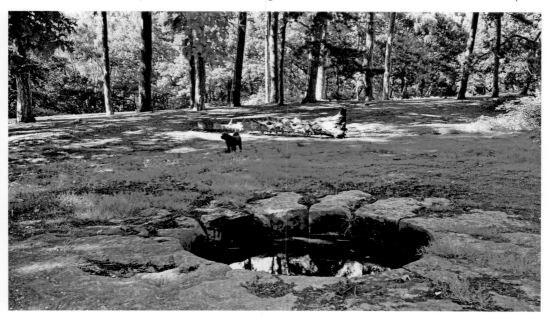

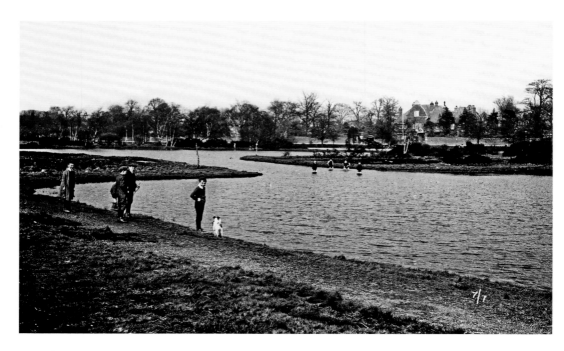

Leg of Mutton Pond, Wimbledon Common

Running alongside Parkside on the eastern edge of the Common, and much wider than it appears from the road, Leg of Mutton Pond is today known as Bluegate Gravel Pit. A pathway once ran through the pond to allow small carts to swell the joints of their wooden wheels in dry weather. Being shallow, it tends to dry up during hot summers, but around its marshy margins thrive dragonflies, including migrant species from the Continent.

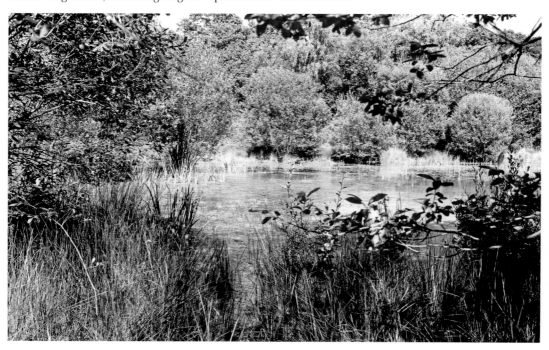

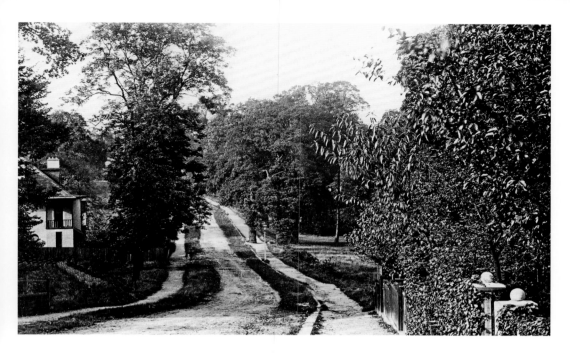

Burghley Road

This view looking northwards is taken from near the junction with Calonne Road. It is named after Lord Burghley or Burleigh, the minister of state in the days of Elizabeth I, and a member of the Cecil family. Another claim to fame is the depressing home in the 1964 film *Séance on a Wet Afternoon* used the house on this road at the corner of Marryat Road.

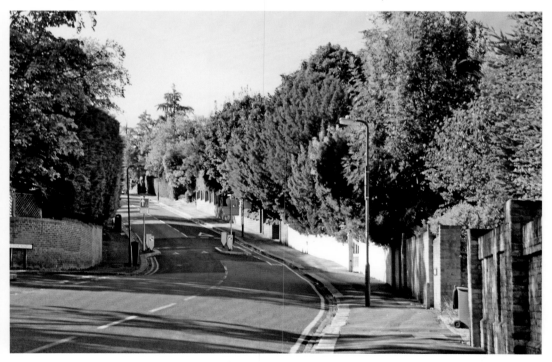

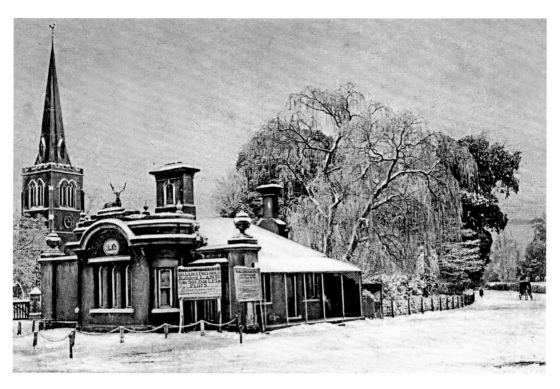

St Mary's Church, Arthur Road

The first notice states: 'Wimbledon Park Estate Valuable Freehold Building Land To Be Sold or Let in Plots'. There has been a church on this site since the eleventh century. The current one, designed by Sir George Gilbert Scott, is the fourth, and the rebuilding was completed in 1843.

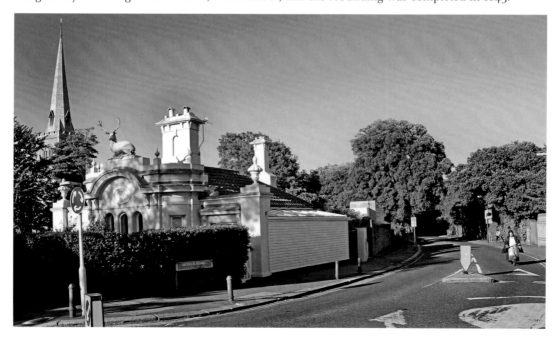

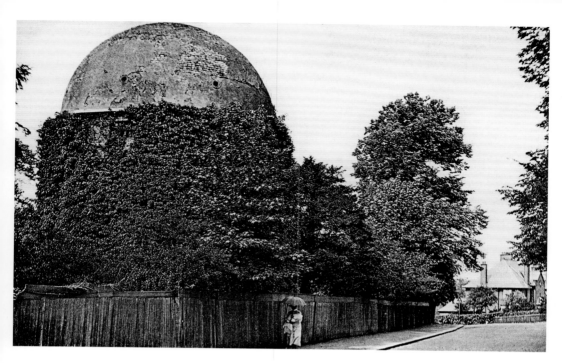

Artesian Well, Arthur Road

As the plaque states: 'Built to provide water for Earl Spencer's house nearby, in 1763. In 1798 the well was increased in depth to over 500ft., but it soon silted up. The building was converted into a private house in 1975.' It is Grade II listed. A horse-operated pump was installed to raise water to a reservoir at the top of the house. But the well was poorly constructed and sand began to seep in, and it was not repairable.

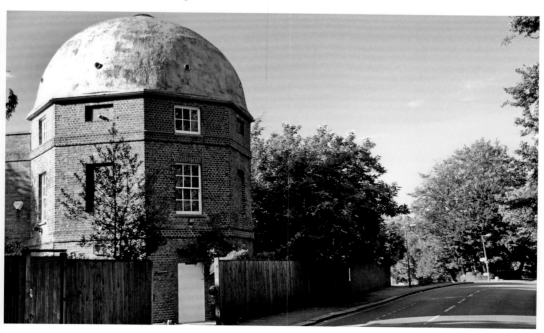

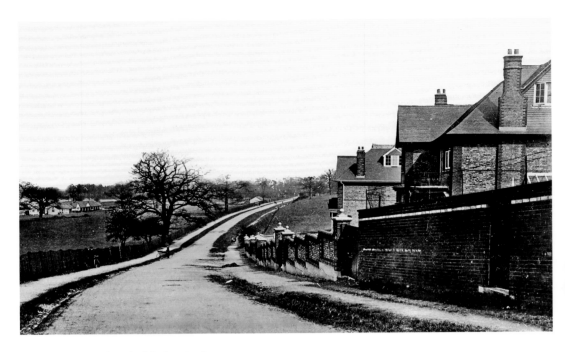

Home Park Road, Wimbledon Park

This is the view from the southern part of the road. The first houses were built at the ends of the road around the 1900s, and the majority of the houses were in place by the late 1920s. Note that the club house is alongside the lake, not where it is now. Also note that there are few trees in this view. In the distance can be seen a group of trees alongside the lake – this is Ashen Grove Wood, hence the name of the nearby road Ashen Grove.

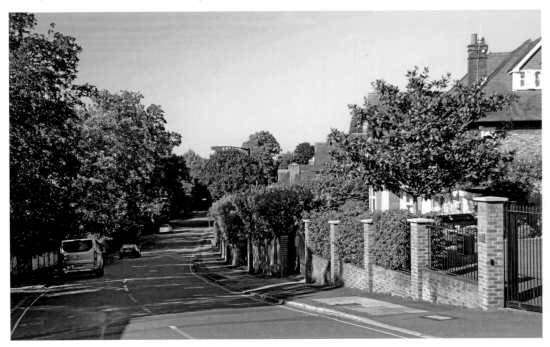

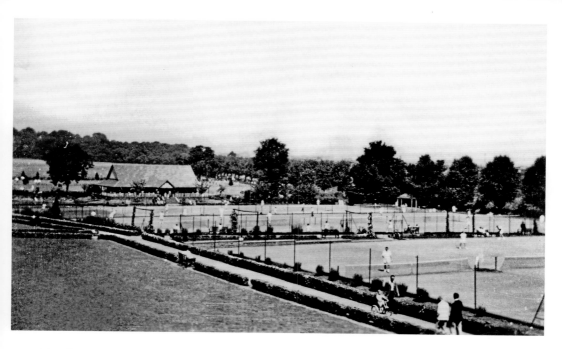

Tennis Courts, Wimbledon Park

[Not the famous ones!] The public part of the park provides a good range of recreational amenities. As well as tennis, there are sports fixtures, bowling greens and playgrounds. The White Pavilion, 1925, is an unusual concrete building (once) used as a police office. Its roof forms a terraced entrance into the park off Home Park Road.

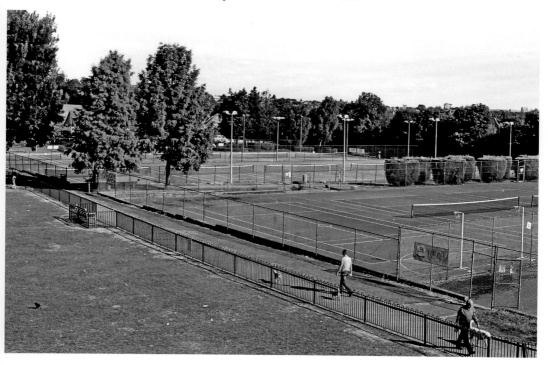

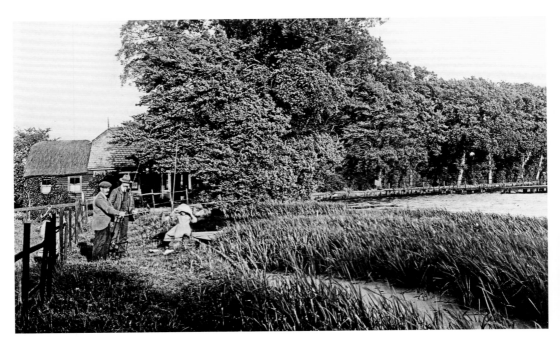

Anglers, Wimbledon Park

Land to the west of the park was sold for the Wimbledon Golf Course and the All England Lawn Tennis Club. As can be seen it was possible to go fishing on the lake. Wimbledon Park itself now consists of 29 hectares for the private golf course, 3 hectares for private sports club, 9 hectares for the lake and 19 hectares for the public park. It is Grade II* listed.

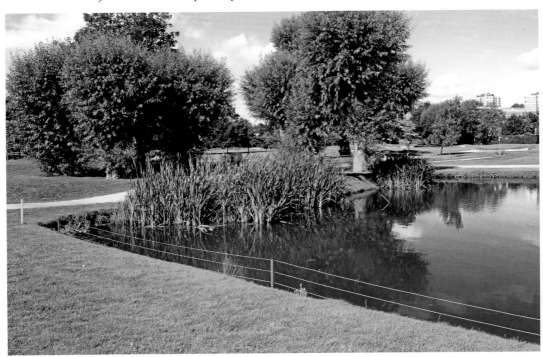

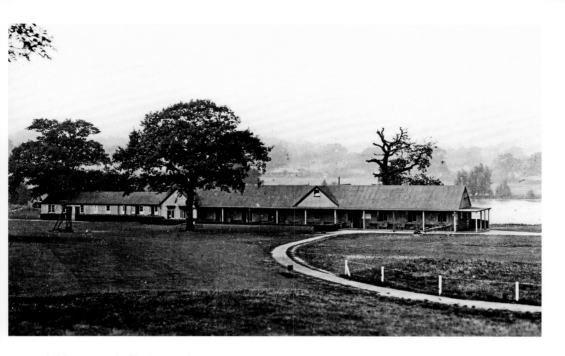

Clubhouse, Wimbledon Park

In 1765, Earl Spencer commissioned Capability Brown to create a park to complement Wimbledon House, which was to be rebuilt by 1802. The estate was nearly 500 ha. During the late 1800s, much of the estate was sold for housing. In 1914, the north part of the (Earl Spencer's) park was sold to the then Borough of Wimbledon. As can be seen above the club house originally was alongside the lake near the southern end. An improved clubhouse is now sited to the north.

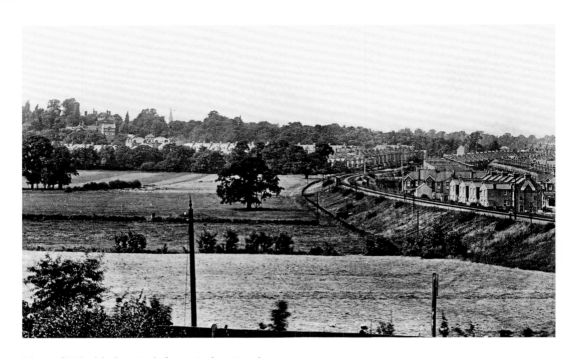

View of Wimbledon Park from Arthur Road

This view is on a card, postmarked 1908, taken from near the junction of Arthur and Home Park Roads. On the right can be seen the first houses on Melrose Road. At the tangent of the railway line is the bridge at the end of Revelstoke Road as an entrance to the park. In the further distance on the left of the railway line is the triangle of houses between Wimbledon Park Road and Gartmoor Gardens.

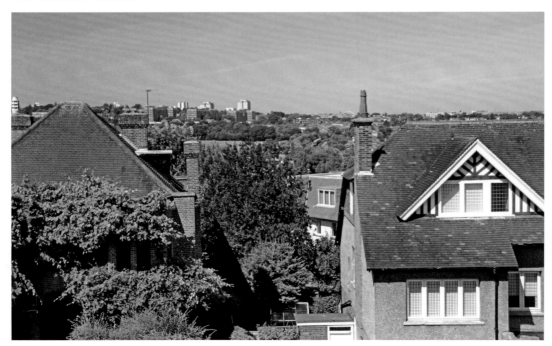

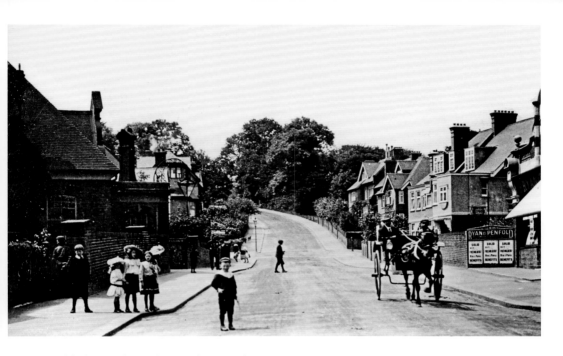

Wimbledon Park Station, Arthur Road

Spot the difference. The earlier view is from a postcard with postmark of 1907, the later one taken in 2016. The buildings are the same, and it is safe to cross the road now. Wimbledon Park station and Southfields station were twins when built in 1889. This station is little changed, but Southfields station has since undergone significant changes.

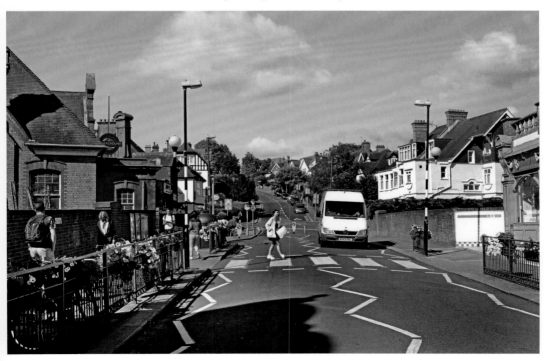

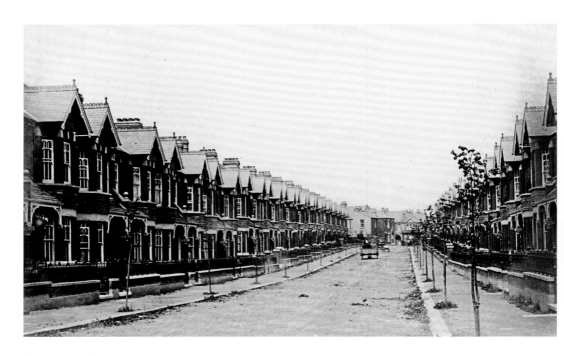

Normanton Avenue

These houses were completed around 1905, and this photograph was taken shortly afterwards. It appears that the surface material has not yet been laid on the pavement and road, partly because the then Wandsworth Council sought payment from the owners or tenants. But the trees have been planted. With curtains and some windows open, at least some of the occupants have arrived.

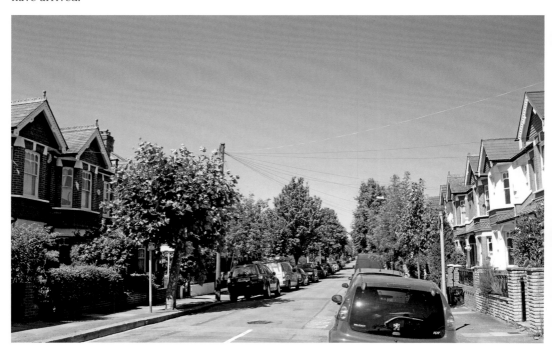

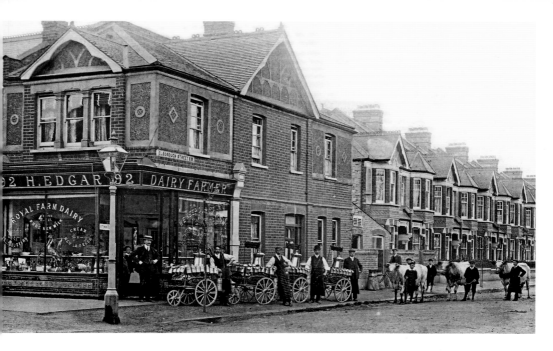

Dairy, Revelstoke Road

At the junction with Elborough Road was an example of the shops at many of the corners of crossing roads. The earlier photograph shows the features of milk delivery. A small shop would arrange the delivery of milk in churns from the farmer, and it was then transferred to another churn on a cart pushed by hand along nearby streets. The milk was measured out into the customers' cans and delivered to the houses. A dairy was still trading at this shop in 1933.

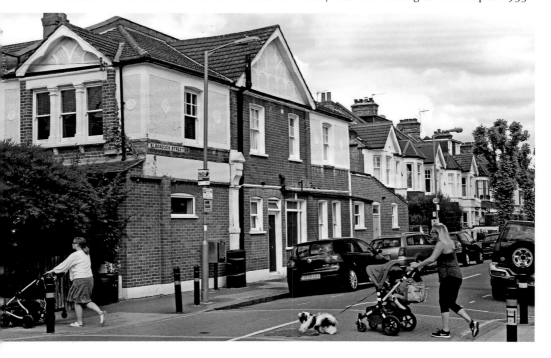

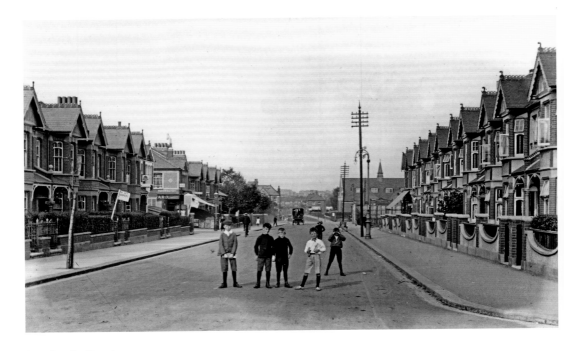

Revelstoke Road

The junction with Astonville Street is on the left with a post office and a grocer's in the corner shops. In the distance on the right is the church at the corner of Ravensbury and Durnsford Roads that preceded the Central Hall. This picture was taken from the junction with Durnsford Avenue on the right. From 1920, another church was on the south-west corner: the Church of Christ, also named the Revelstoke Tabernacle.

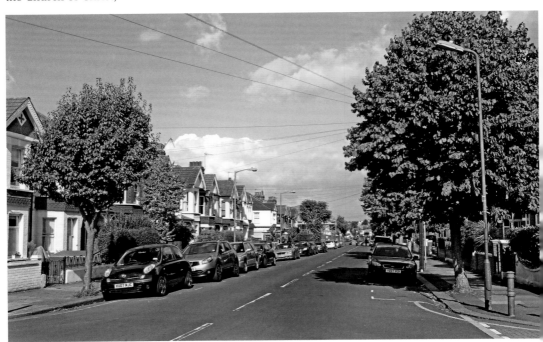

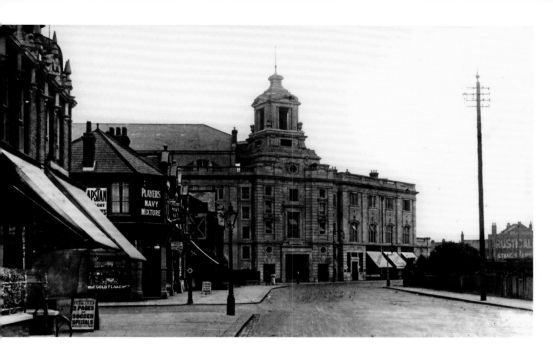

Central Hall, Merton Road

In 1905, a Wesleyan chapel started initially in Merton Road School and then moved to the church in Ravensbury Road (the church can be seen opposite). Expansion was rapid and it was replaced in 1925 by the much larger Central Hall on the corner of Ravensbury and Durnsford Roads. Music concerts and film shows featured for many years. It was redeveloped in recent years to provide flats, but the church continues.

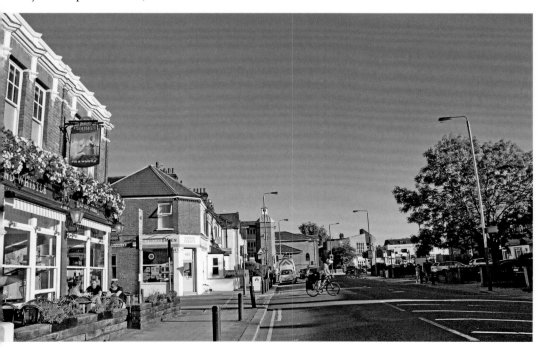

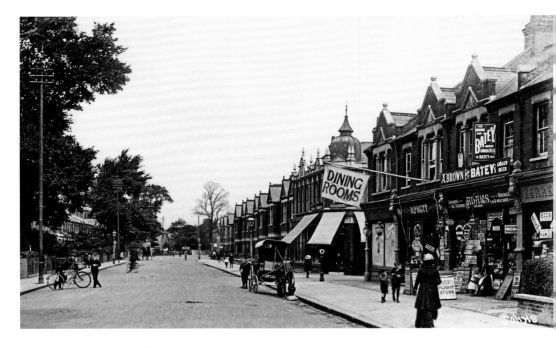

Merton Road at Penwith Road
This view is at the junction with Penwith Road. Between the wars, the shops on this side of the junction included a boot and shoe retailer, dining rooms, a tobacconist/newsagent, and a grocer. The earlier picture shows there was a period when the corner shop was not trading. The further corner shop was an off-licence. In 1974, that became a pub, the Pig & Whistle.

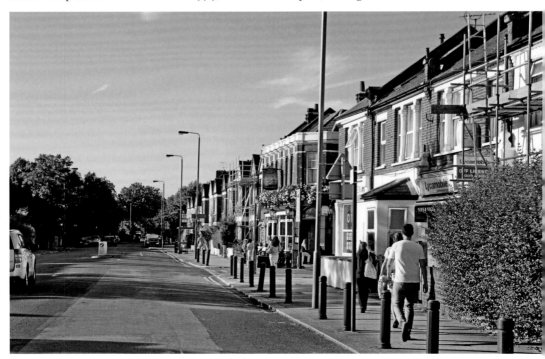

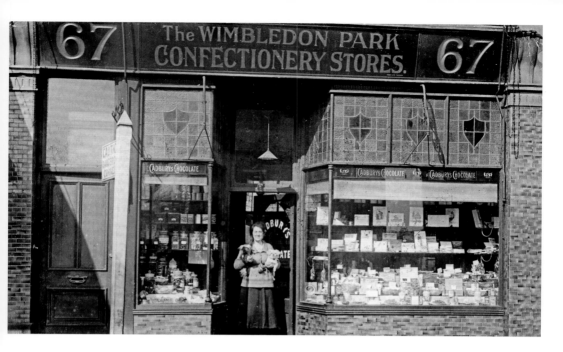

Confectioners, No. 67 Lavenham Road

As mentioned elsewhere in this book, many of the corner houses had small shops. No. 67 Lavenham Road, at the corner with Engadine Street, started as a baker's. In 1931, Juiseppina Peters opened a confectioner's. (Is she in the photograph?) It changed hands two years later but continued the trade, with the building being shared with a boot repairer. Now, as with many other corner shops, it has been converted to a house.

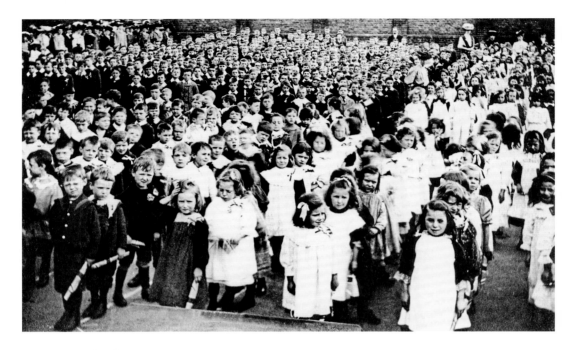

Riversdale School

In the years around 1900, the dramatic increase in the number of houses being built required a rapid increase in the numbers of school places. Merton Road School opened in 1890 at the corner of Replingham and Merton Roads. That school was enlarged in 1902. But by 1905, a new school was built on the other side of Merton Road, to the south of Burr Terrace.

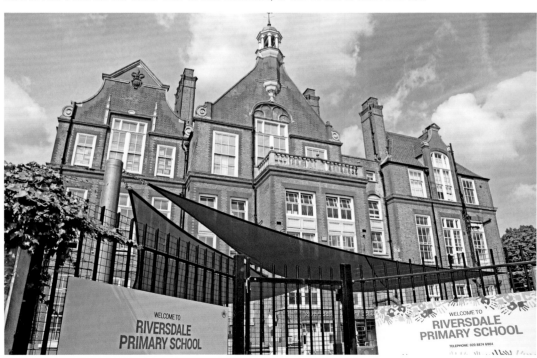

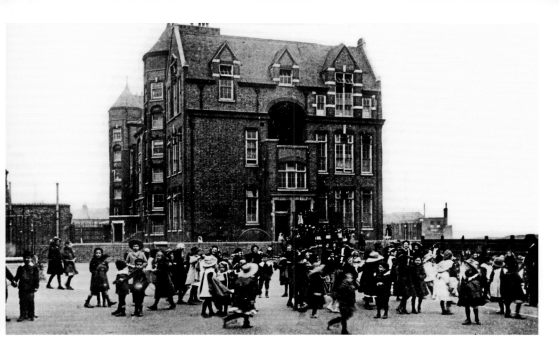

Riversdale School

By 1914, there were three schools on the eastern site: Riversdale, Southfields and The Elliott Central. The former was the three-storey block as seen above. Eventually, that building and the whole site was taken over by Southfields School. Merton Road School took over the name, Riversdale. The Elliott school moved to a site in Putney in the mid-1950s. A farm was situated next to the schools, Dunsford Farm, but by 1930 the site was used by motor engineers.

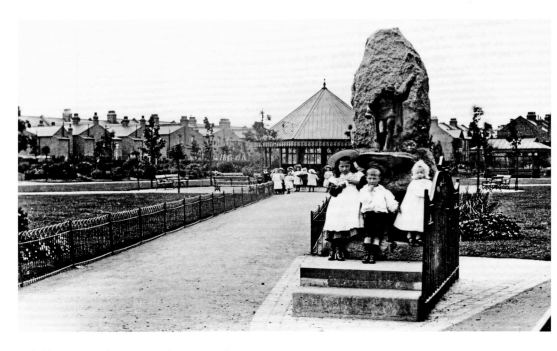

Drinking Fountain, Coronation Grounds

This small park is at the corner of Merton Road and Pirbright Road. It commemorates the coronation of Edward VII in August 1902. A local paper called it 'Wandsworth's new lungs'. The drinking fountain is described as 'rough hewn granite with Art Nouveau-style bowl and ornamental railings to one side'. The plaque that named the fountain's donor is no longer in place.

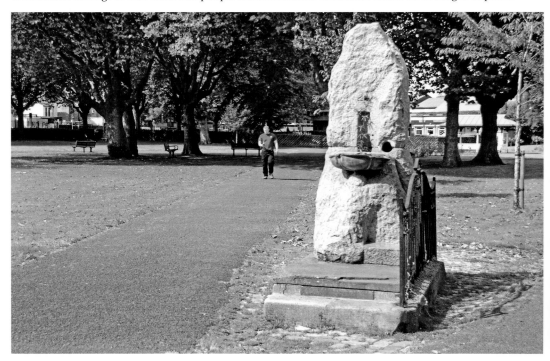

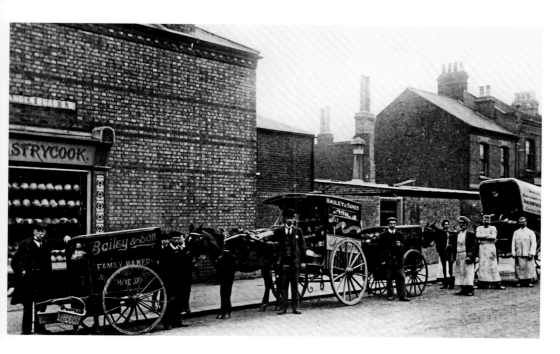

Standen Road

This photograph was taken from the junction with Merton Road. Note the bakers shop on the left has been rebuilt. The house at the start of the terrace on the right has its roof and upper windows lifted. The older view shows chimneys in the space between the buildings where the baking took place.

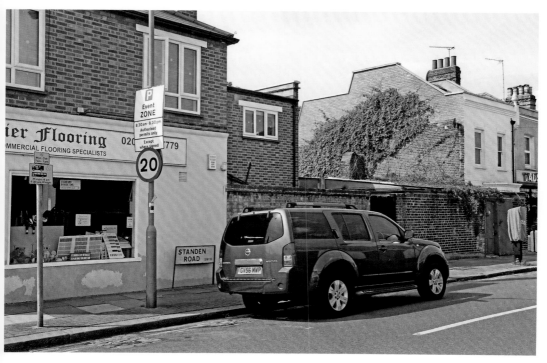

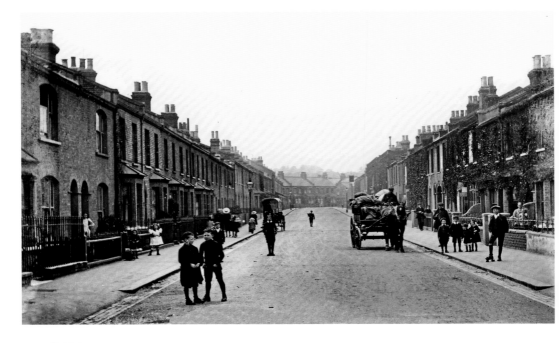

Longfield Street

The 1867 Ordnance Survey (OS) map shows that this road was soon to be built. At that time, a terrace of houses had been built on the south side of Smeaton Road. On Merton Road, eight semi-detached houses were in place running north from Smeaton Road and a terrace of four buildings and a public house ran south. The land had already been marked out for the houses on both sides of Longfield Street. Also identified was the footpaths to go at the back of the houses on those two roads.

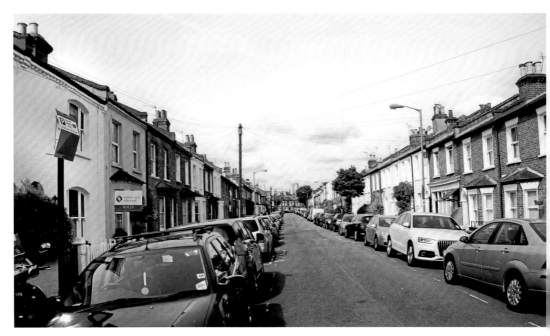

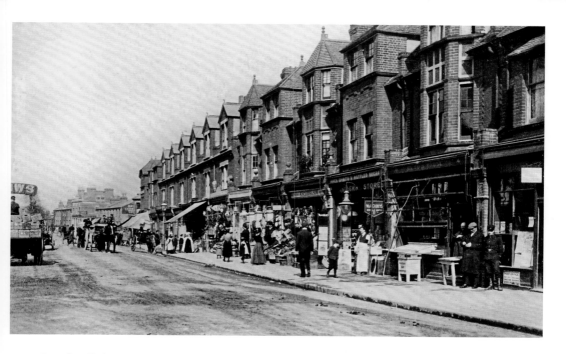

Parade of Shops, Merton Road

Opposite the Park Tavern. A typical run of shops that families (or rather the mother, or maid/cook if for a larger house) would usually visit daily to buy food. Along here we have a post office (with a public telephone), fishmonger, off-licence, greengrocer and fruiterer, tobacconist, general store, grocer and butcher. Street lighting was limited, so shops often provided lights outside their windows.

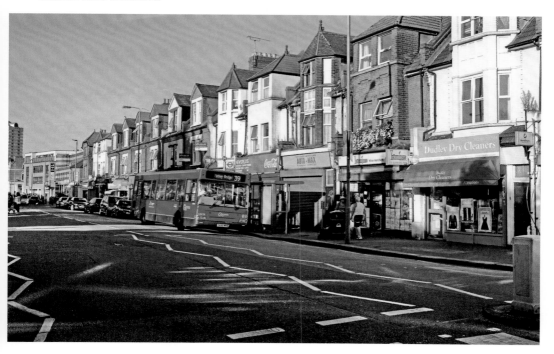

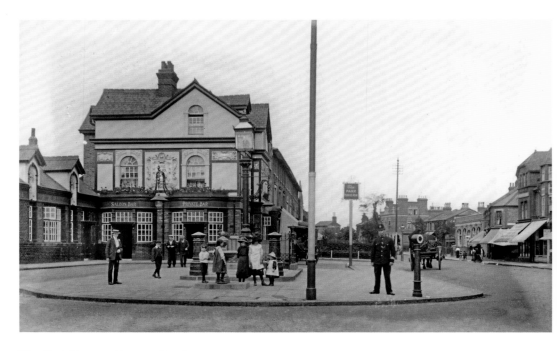

The Park Tavern, Merton Road

Note the two bars – Saloon and Private. Pubs used to (and some still do) have public and saloon bars; the public for the working class with bare boards and hard seats and cheap(er) beer. People who could afford a higher price would use the saloon bar with carpets and cushioned seats. Some pubs also had a private bar (or 'snug') with frosted glazing so the drinker would not be seen. The price would be even greater. Note behind the children is a drinking fountain. Next to the policeman is a post with a ring at the top. It is a fire alarm – break the glass to call a fire engine.

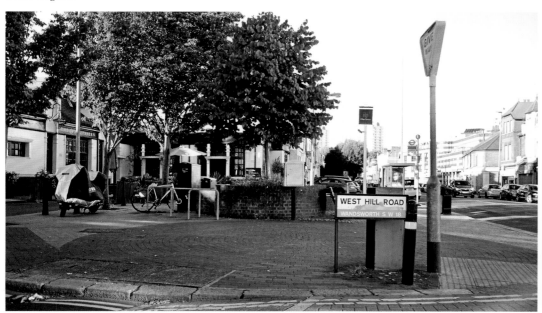

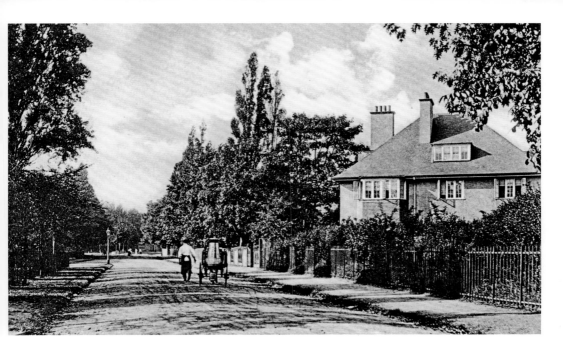

Viewfield Road

By the beginning of the 1900s, this road had only four large properties on the west side near West Hill Road and one cottage on the east side near Merton Road. In 1902, the house in the picture was built. It became the Vicarage of St Michael and All Angels and housed the then vicar, Revd Richard Augustus MA. No more houses were built on this road until the 1920s.

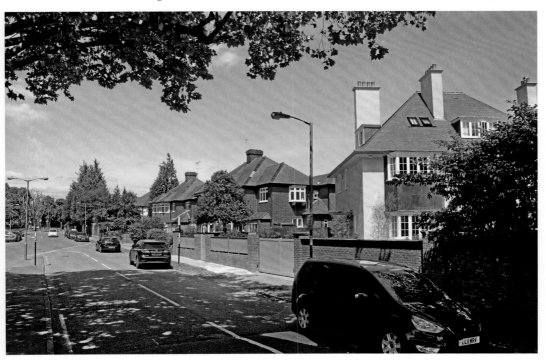

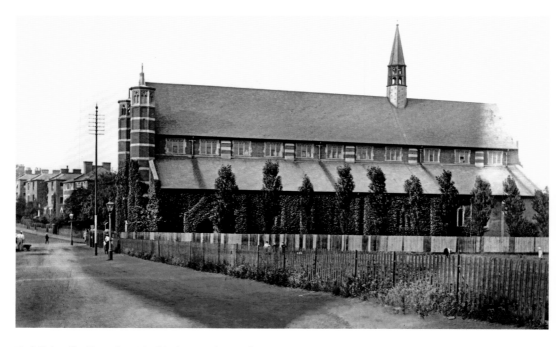

St Michael's Church, Wimbledon Park Road

Looking north towards the junction with Granville Road at the Grade II Church of St Michael and All Angels, which was dedicated in 1898. The houses at this part of the road were the last ones to be built on this side of the road. The church was designed by E. W. Mountford, who was also responsible for Battersea Town Hall. Note the spire in the middle of the roof was removed at a later date.

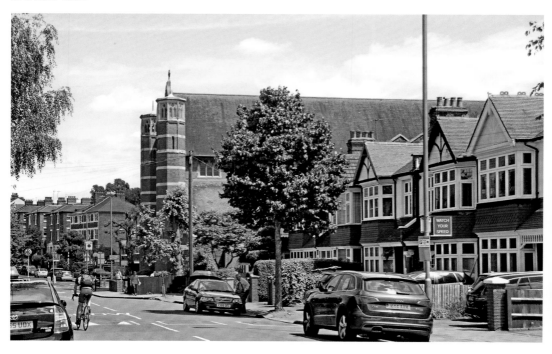

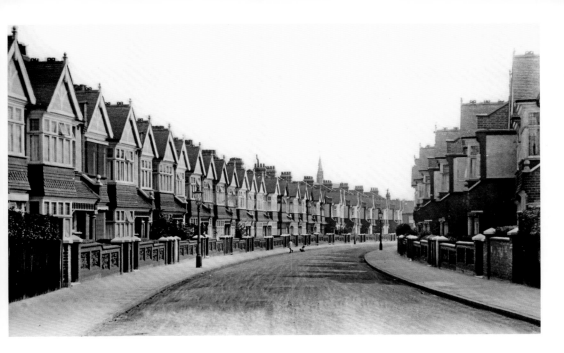

Wincanton Road

The houses here are typical of the group of properties of four that also include Hambledon, Gatwick and the adjoining part of Wimbledon Park Road. They were built between 1910 and 1920 by the developers Allen & Norris. Their distinctive features are clinker-brick walls, windows typical of the Edwardian period, original garden paths in black-and-white tiles and timber front doors with distinctive etched-glass panelling.

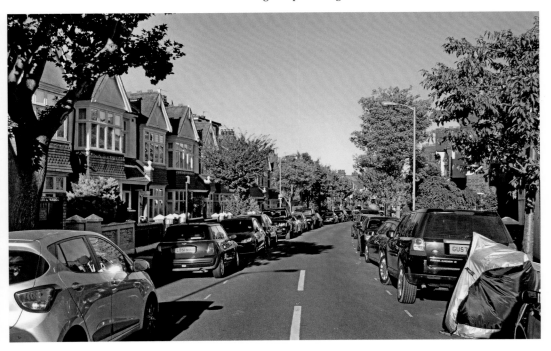

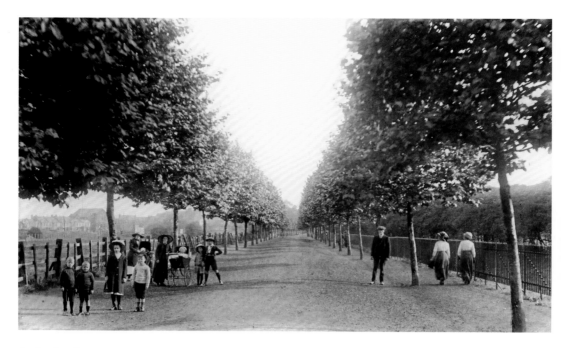

Sutherland Grove

Looking southwards from near the middle of the road. The area to the right (i.e., to the west) was mainly open fields on what was called Leg of Mutton Hill (*see* page 92). The roads to the east were laid out when the railway extension to Wimbledon opened in 1889. On the left of the older view (*c.* 1915) can be seen houses on Wimbledon Park Road before the even numbers 174 and upwards were built. What is now Everyday Church at the corner of Pirbright Road was then a Baptist church.

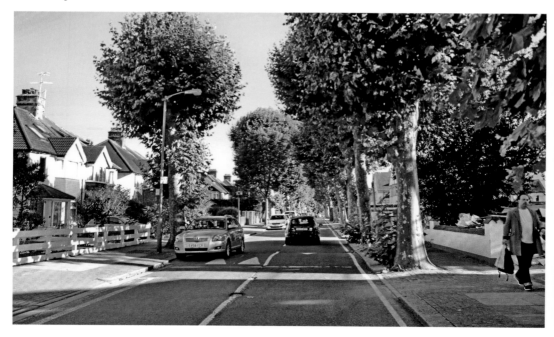

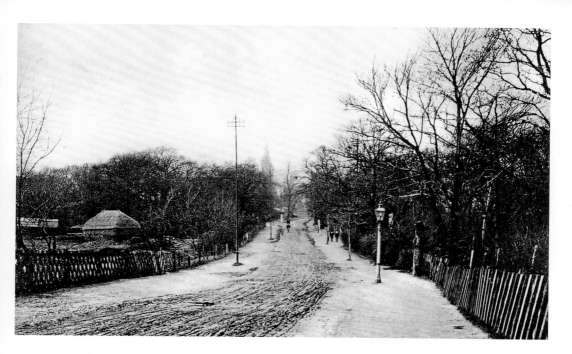

Haystack, Augustus Road

Looking up Augustus Road from near the station, probably around 1905–10. Several features show an older life: unmade road, old woodland on both sides, haystacks indicating it is still agricultural land, and a horse being ridden up the rise of the road. But the new life is coming: telegraph poles on the left of the road and street lights on the right. And behind the photographer on the other side of the railway line, houses were already being built.

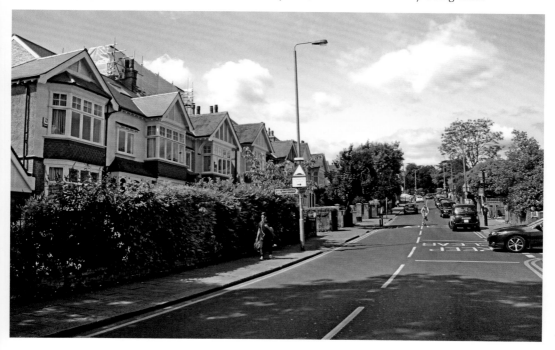

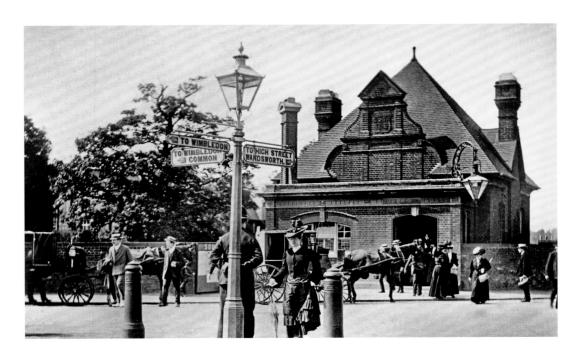

Southfields Station

As noted in the brickwork on the outside of the station, the line from Putney Bridge to Wimbledon was built by the London & South Western Railway and opened in 1889 by the District Railway. Initially it used steam engines, changing to electric power in 1905. The line stayed in British Rail ownership until 1994 when taken over by London Underground. Wimbledon Park and Southfields stations were built at the same time and were to the same design. The former has had few changes, but the latter has undergone many.

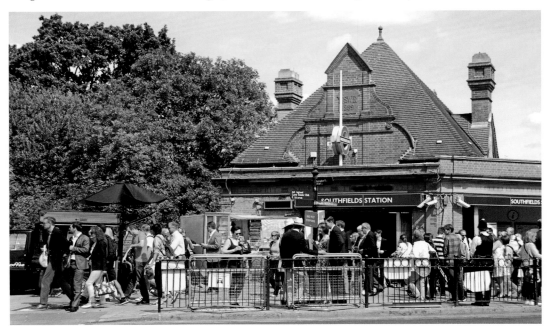

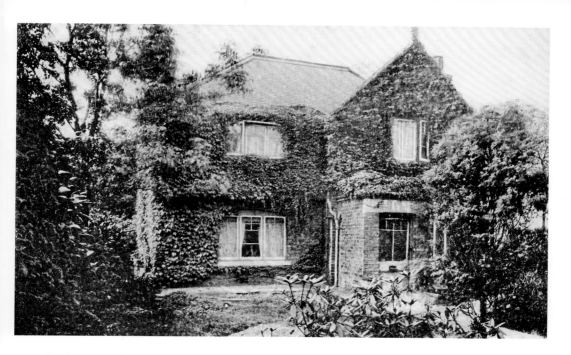

Stationmaster's House, Southfields Station

In the early days of rail, all, or most, railway stations had station masters who worked to a rule book. Their responsibilities included managing the station staff, ensuring safety, maintaining good appearance of the station, security of the buildings and ensuring the flow of traffic among other things. Most station masters were provided with a house built as part of the station or nearby. At Southfields station, this was beside the 'down' side on the land behind where the estate agents' building is now.

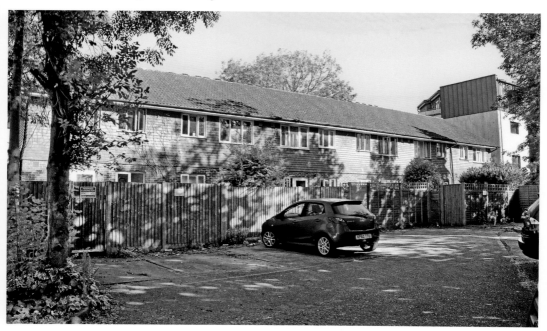

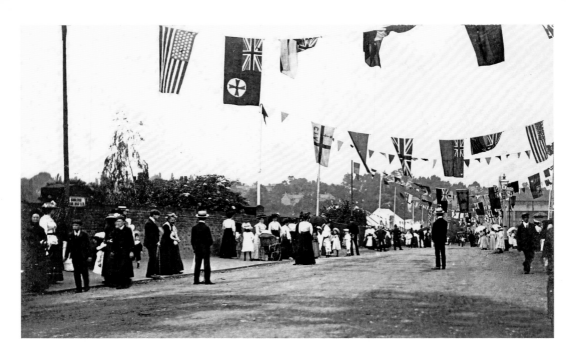

Royal Visit, Wimbledon Park Road

Looking northwards from outside the station. The postcard has a postmark of September 1905. The message reads: 'This is to wish you Many Happy returns of your Birthday. Thought you might like to see snap-shot of the Flower Show. Can you see A. May & Jim & myself? it's taken up by the station when we were waiting to see Princess L. With love. Olive. ('L' probably refers to Princess Louise, daughter of King Edward VII, two months before she became the Princess Royal.)

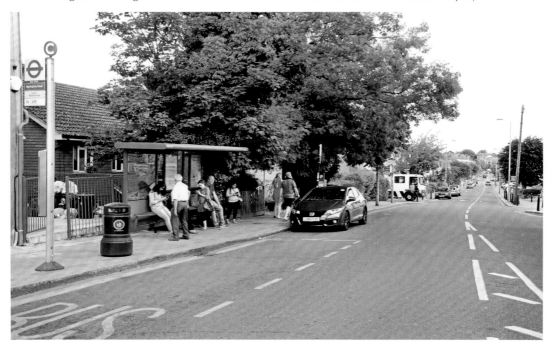

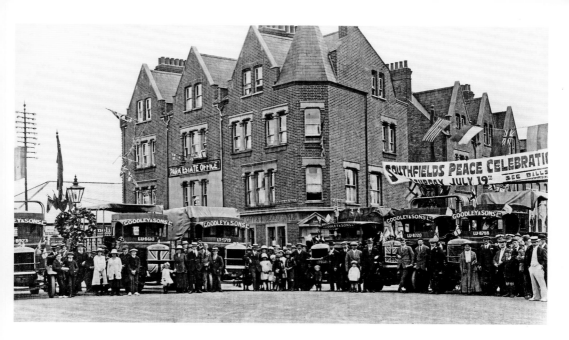

Peace Celebrations, Wimbledon Park Road

At the junction with Replingham Road, showing celebrations on Saturday 19 July 1919 at the end of the First World War. Goodley's Garage Ltd was a local haulier based at No. 15 Replingham Road. To the left, I presume, is the roof of the cinema on the corner with Pirbright Road. The Lyceum opened in 1917, and after some changes of owners and names, it finally closed in 1969. It was later used as a snooker hall. Despite a strong, valiant campaign to reopen as a cinema, in 2013 the planners decided that it could be rebuilt.

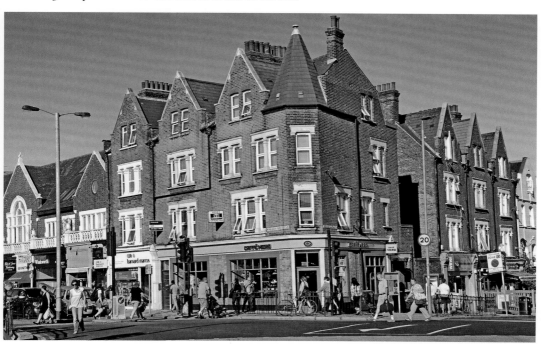

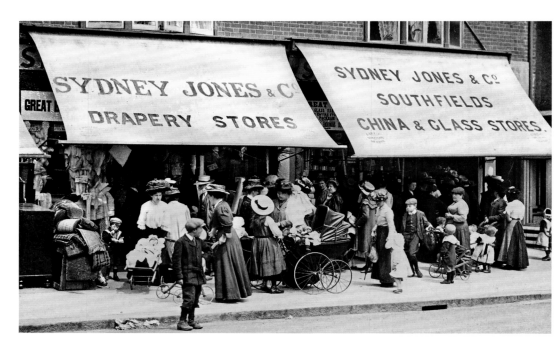

Shops, Nos 77–79 Replingham Road

This road was an important shopping road in the first half of the twentieth century. The 1933 *Kelly's Directory* listed on the south side thirty businesses, and on the north side fifty-three. In 1908, Sydney Jones started as a draper and expanded to add a china and glass store. Though the younger children look less interested, the women are enjoying the opportunity to talk to their neighbours. In 1914 Sydney stopped trading.

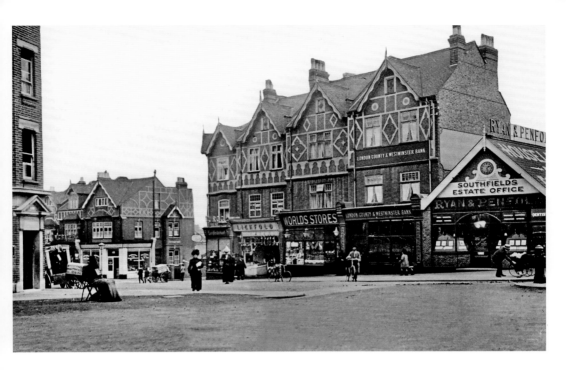

Parade of Shops, Replingham Road

In addition to the numbers of businesses mentioned opposite, there were twenty-three businesses in this part of Wimbledon Park Road. Overall, here and in Replingham Road there were three banks and three estate agents. The begging man seated on the left is probably an injured soldier from the First World War.

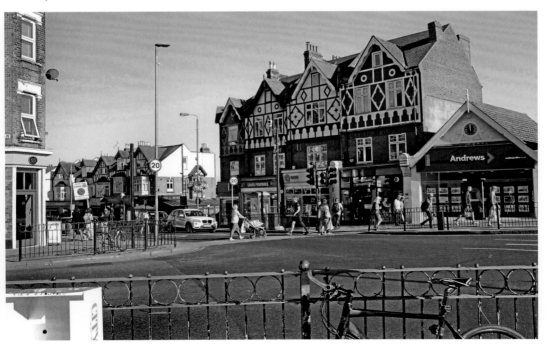

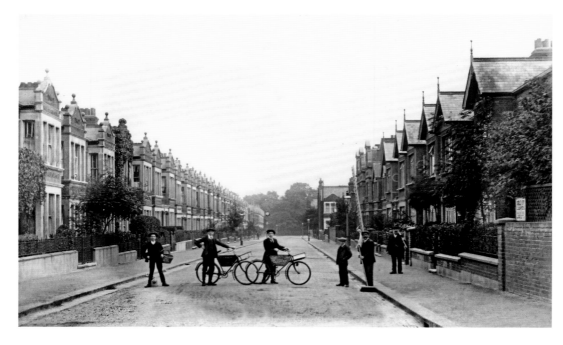

Gartmoor Gardens
An era when it was easy to park your horse and cart (though where would you put the horse overnight?). For younger men, a first job could be delivery boy, either on foot (with a hand basket) or on a heavy bike with a carrier on the front. All are wearing hats. Note on the right the window cleaner (?) carrying a single, long ladder.

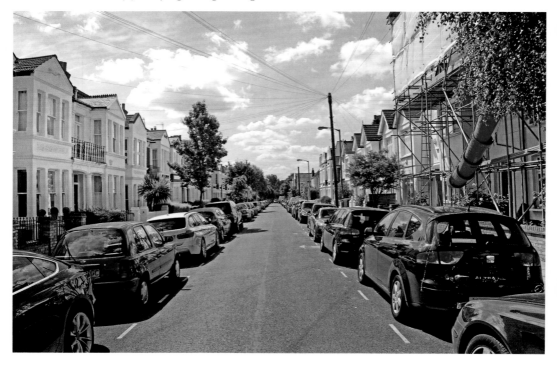

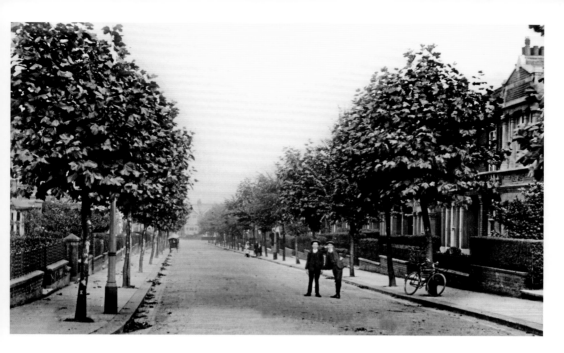

Southdean Gardens

The houses here were built before 1908. The gardens on the south side back on to the northern part of Wimbledon Park with Horse Close Wood, a small patch of old planted woodland, largely consisting of ash and oak. The wood is on the oldest maps and may have survived from the ancient forest that once covered the entire district.

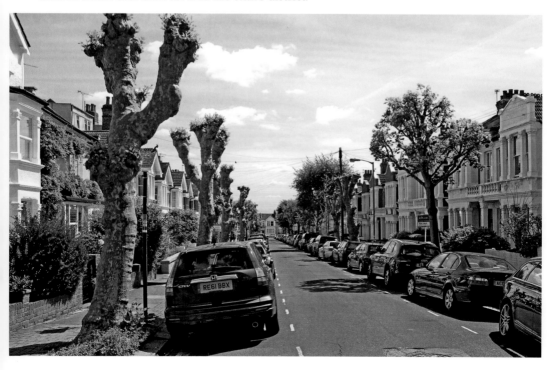

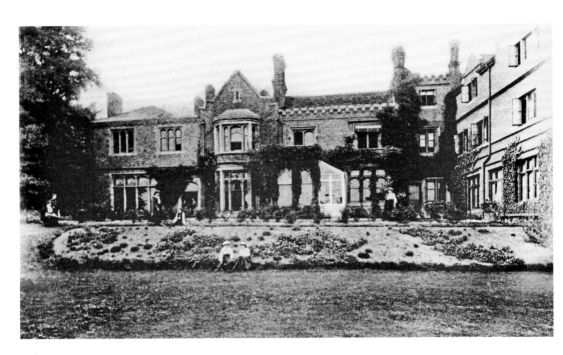

Allenswood House, Wimbledon Park Road

Built on a large piece of land between Albert Road and Wimbledon Park Road, in 1870 it became Allenswood Boarding Academy for girls. It was founded by Marie Souvestre, helping shape young girls into independent, forward-thinking young women. Eleanor Roosevelt attended from 1899 to 1902. The school closed in the early 1950s and was later demolished; a block of flats built on the site keeps the same name.

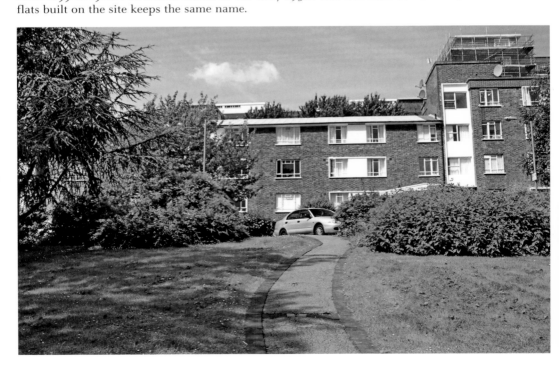

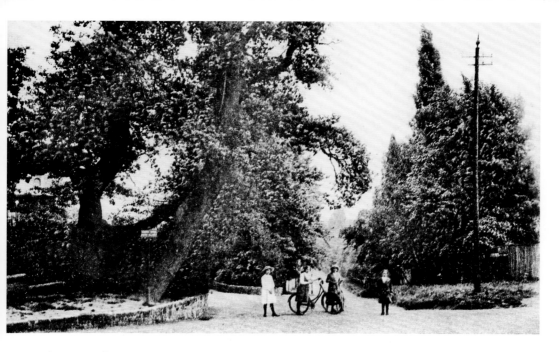

Princes Road

Looking south at the junction with Albert Drive (then Road). In the 1880s, Princes Road had along its length a few large buildings in their own estates. From the 1930s, they started to be taken over for other purposes, including, in the 1940s, colleges of automobile and aeronautical engineering. Villas were pulled down to be replaced with terraces and blocks of flats. Also see pages 92 and 94.

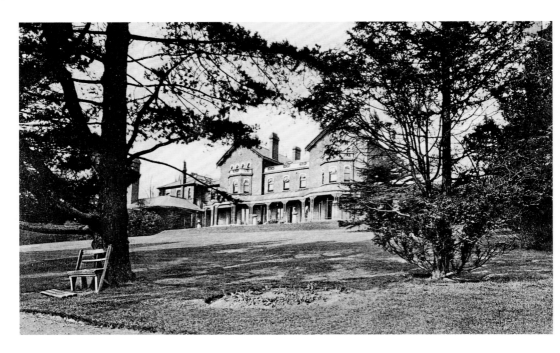

Oaklands, Albert Drive

This country villa was to the west of the junction of Princes Road (now Way) and Albert Road (now Drive). In the later 1920s, it was occupied by Countess Oei Tiong Ham, a relative of a very wealthy Chinese Indonesian businessman who died in 1924. The villa was used by the Brothers of St Gabriel's School of Languages throughout the 1930s. The site is now occupied by the Oaklands Estate.

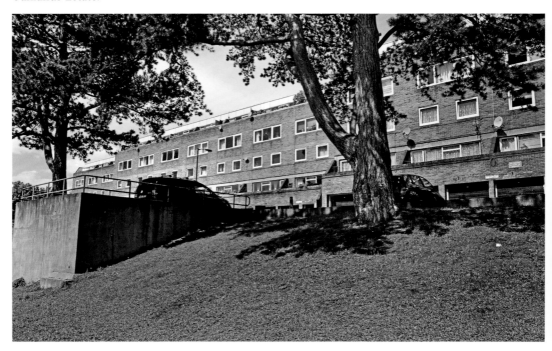

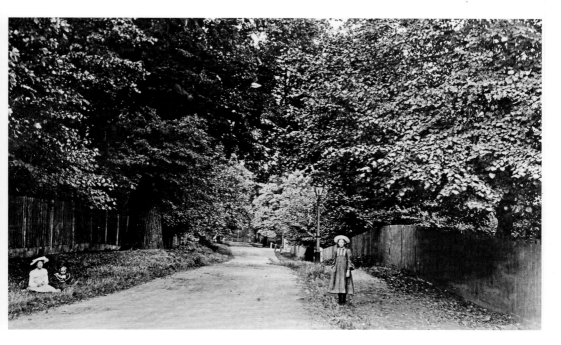

Albert Road

Now Albert Drive. From the 1867 OS map, there were a good number of large houses along Parkside and Inner Park Road. But the density of housing reduced moving eastwards until there was open ground near Merton Road. Albert Road had one villa, Fernwood, and four smaller houses. There was also a remnant of woodland that was still there on the 1913 OS map.

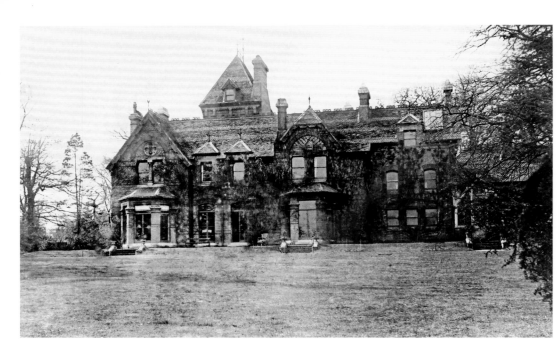

Torwood, Augustus Road

Built in the mid-1860s on northern site of the junction of Princes Road and Augustus Road. In 1865, a Mr Gale from Plymouth demonstrated here his 'non-explosive gunpowder'. When mixed with pulverised glass, it is safe for stowage and transport, and after sifting out the glass the powder returns to its explosive state. There is no evidence that this had any connection with an advertisement in the *Nursing Record* in 1892 seeking a 'Nurse-attendant wanted for invalid Gentleman' living in the house.

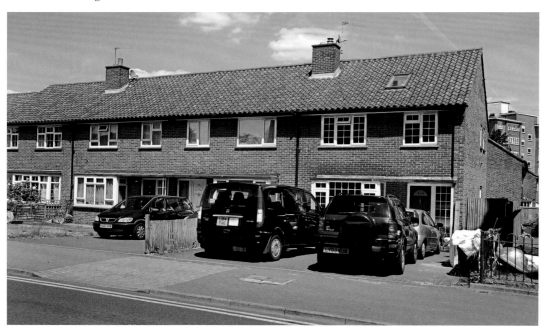

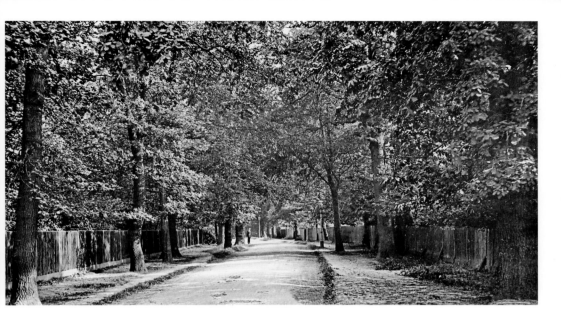

Victoria Road

Renamed Victoria Drive in 1936. Originally, it was a grand road through the estate of the Spencer family. The estate was sold in the 1840s, which led to parcels of land being sold for development, initially for large country houses and then smaller villas. Some of these can be seen on other pages. But by the early years of the twentieth century, the last large villas had been built along Albert Road (renamed Albert Drive in 1936). Terraced housing was built in roads to the east of the railway line between Fulham and Wimbledon. In the 1920s and 1930s, developers built what nowadays we consider to be large houses with large front and back gardens in the area between Wimbledon Park Road and Inner Park Road.

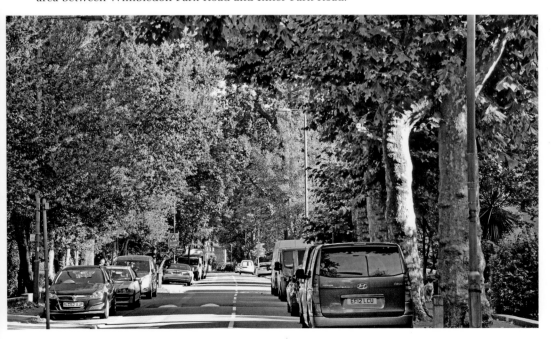

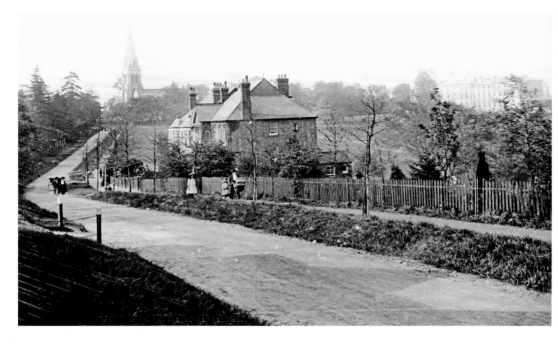

Church & Royal Hospital from Beaumont Road

In the distance on the left can be seen the Holy Trinity Church built in 1863 with the tower added in 1888. The Royal Hospital, on the right in the distance, moved into its current building in the same year. It took on the title Royal Hospital and Home for Incurables in 1917 and later changed to the Royal Hospital for Neuro-disability to better reflect the nature of its work. Two Victorian houses are in the foreground. The rising land was known as Leg of Mutton Hill within the grounds of Edgecombe Hall, a large villa out of shot to the right.

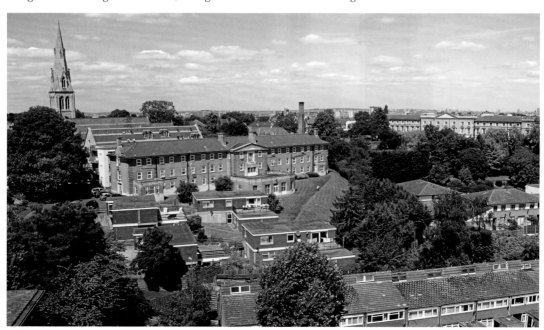